IMAGES
of America

YAPHANK

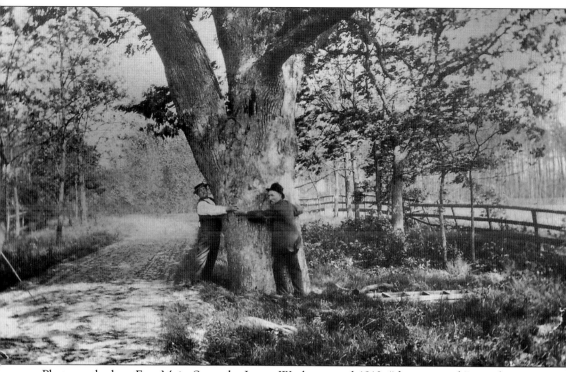

Photographed on East Main Street by James Weeks around 1910, "the great oak" stood across from The Lilacs, Clara Weeks's home, on the carriage road. A landmark on the eastern edge of the village until the 1950s, this oak tree was a popular meeting place for villagers for many years. (Courtesy Kenneth B. Hard.)

ON THE COVER: An 1890 Fourth of July celebration on Gerard's Mill Pond was described by W.L. Denton in the *Yaphank Courier*: "The night before someone generously visited each house and left an American flag. At sunrise, day was ushered in by the ringing of bells and firing of guns, repeated at sunset. In the evening all gathered on the Presbyterian Oak Villa lawn to watch fireworks and enjoy ice cream and cake." (Courtesy Nathalie Dickieson.)

IMAGES
of America

YAPHANK

Tricia Foley and Karen Mouzakes
Yaphank Historical Society

ARCADIA
PUBLISHING

Published by Arcadia Publishing
Charleston, South Carolina

Printed in the United States of America

Library of Congress Control Number: 2012935261

For all general information, please contact Arcadia Publishing:
Telephone 843-853-2070
Fax 843-853-0044
E-mail sales@arcadiapublishing.com
For customer service and orders:
Toll-Free 1-888-313-2665

Visit us on the Internet at www.arcadiapublishing.com

Dedicated to William J. Weeks and his legacy to Yaphank

CONTENTS

FOREWORD

Yaphank is a special place. At our monthly Yaphank Historic District meetings, when we plan the future of its past, we swap stories about the locals and invariably always come to the conclusion, "Only in Yaphank!" Yaphankers are a hardy lot as they fight to retain the precious relics of their past. The Robert Hawkins House was slated for demolition when the Yaphank Historical Society rallied and persuaded Suffolk County to allow them to restore the house in 1976. The Hawkins House, which was dedicated to the Suffolk County Historic Trust in 1984, was opened to the public in 1986. The Suffolk County Historic Trust program promotes the restoration of county-owned historic structures within their communities with the help of local historic societies. As the community battles to protect its historic district from the development pressures of the surrounding suburbs, they are saving one of the earliest colonial settlements on Long Island. The Yaphank Historical Society was recognized for their efforts in 2005, when they were awarded the Robert H. Pelletreau distinguished service award in historic preservation from the Bellport-Brookhaven Historical Society. I salute all their efforts and hope this book inspires others to join in their work to have Yaphank's history recognized, appreciated, and restored for all to enjoy in the future.

—Richard C. Martin
Director of Historic Services
Suffolk County Parks Department

ACKNOWLEDGMENTS

On this journey into Yaphank's history, it was exciting to weave stories together of the people and places that created this village. With our time period, 1720–1920, we were fortunate to have a guide to the past in L. Beecher Homan's *Yaphank As It Is and Was. Its Prominent Men and Their Times*, published in 1875. His observations on the people and culture of this small-town life were invaluable. We were fortunate to have three resident photographers, Edmund Hammond, Cadet Hand, and James E. Weeks, who in the late 19th century documented the landscape and houses and took portraits of eminent citizens. The diaries and journals of the Weeks family were courtesy of Elizabeth and Robert Martino.

The Yaphank Historical Society was founded in 1974 to save and foster the preservation of 19th-century houses in the historic district and its surrounds. Many people helped us in tracking down photographs of the mills, houses, and schools that are now long gone but so important to our story: Suzanne Johnson and Melanie Cardone Leathers of the Longwood Public Library and Bayles Collection, Barbara Russell of the Brookhaven Town Historian's office and the David Overton Collection, and Mary Laura Lamont of the William Floyd Estate. We would like to thank Richard Martin and Lillian Fais of Suffolk County Historic Services as well as Robert Kessler, president of the Yaphank Historical Society, for their enthusiastic support. Edythe Davis lent us her postcards and family photographs, and Olive Archer shared her family archives and the scrapbook of St. Andrews Episcopal Church. Rev. Richard Chapin's book, *Little Susy's Church*, was invaluable in our research. We would also like to thank friends Jeff Weinstein for his editorial eye and William P. Steele, Jeanne DeVito, and Rob Seifert for their help, along with those who lent us their photographs and family stories: Jane Cardi, Ann Englehardt, Jim Hololob, Paul Infranco, Gary Ralph, Steve Trusnovec, Kay Walters, Carol and David Dew, Kenneth B. Hard, and Shirley Olsen. A thank you goes to Andy McLaughlin for his technical assistance and to our editors, Abby Henry, Erin Rocha, Rebekah Collinsworth, and Ryan Easterling, for making this book possible.

INTRODUCTION

Not a town, not a village, but all roads nonetheless lead to Yaphank. Situated between its two lakes in the town of Brookhaven, Yaphank is nearly the geographic center of Long Island. In the 17th century, the Unkechaug Indians, who had their headquarters in nearby Mastic, built temporary campsites near what was later known as Weeks Pond while they hunted waterfowl on the Carmans River. According to Brookhaven town records, the Unkechaugs were disarmed in 1689, even though they had always shown themselves to be peaceful. By the time early settlers reached the river area in 1726, however, the Indians had sold their land and given up fishing and hunting rights. Finding it hard to survive, many of the Indians worked for the new landowners.

In 1739, Capt. Robert Robinson was granted permission to dam the river and build the Upper Mill, or Swezey's Mill. Twenty-three years later and farther downstream, John Homan was granted the right to build a sawmill and later a gristmill below his house on the river. The road that ran along its northern bank between the mills became Main Street, and the village that was centered there became known as Millville. In 1800, Millville was an "almost unknown hamlet of twenty houses," according to Homan's *Yaphank As It Is and Was. Its Prominent Men and Their Times,* and primarily a farming settlement, but the milling industry allowed the village to thrive and grow. In 1844, the Long Island Railroad was extended through the village, and by 1845, Millville had changed its name to Yaphank, based on the Native American word *Yamphanke,* or "the bank of a river."

By the 1850s, Yaphank was busy with sawmills and gristmills, two wheelwright shops, a meat market, a dry goods and hardware store, upholstery shop, and an express stagecoach line. During this period, Episcopal, Presbyterian, and Baptist churches were established.

In 1875, L. Beecher Homan, a local newspaper editor who grew up in Yaphank, wrote a book called *Yaphank As It Is and Was and Its Prominent Men,* in which he tells the stories of prominent residents among its "800 souls." Its most illustrious citizens, the Weeks family, came to Yaphank in 1828 when James H. Weeks and his wife, Susan Maria, built their home, The Lilacs. As director and later president of the Long Island Railroad, James Weeks brought the train to Yaphank. Their only son, William Jones Weeks, attended Yale, where he started the Yale Navy. Weeks was a proponent of octagonal architecture and designed his home and the village school on Main Street using this style. Only the foundation of the house remains today and is located near Weeks Pond, but it can still be seen on the Carmans River Nature Trail. William Sydney Mount painted the portraits of James and Susan Weeks that are in the Long Island Museum's Stony Brook collection.

Robert Hawkins, who purchased Homan Mills in 1821, was a wealthy farmer and landowner. He and his descendants controlled the lower mills for the next 100 years. His son Robert Hewlett Hawkins built a Victorian Italianate country house on the bank of the lower lake that today is owned by Suffolk County and maintained by the Yaphank Historical Society.

Christopher Swezey and his sons operated Swezey's Sawmill next to the Swezey-Avey House. The white clapboard lakeside residence remained in the family until 1963, when the Town of Brookhaven purchased it.

William Phillips is remembered for his service during the Revolutionary War, when he was captured by the British and traded back in a prisoner exchange. He served William Floyd, a signer of the Declaration of Independence, and was granted land in gratitude. That first residence was later replaced, but the family retained the original land grant signed by Floyd.

During the war, patriot Benjamin Tallmadge came from Connecticut to take the British-occupied Fort St. George at the Manor at Mastic. He marched through Yaphank and stopped to water his horses at the Phillips residence. Today, markers guide hikers along the Benjamin Tallmadge Historic Trail, which runs through Yaphank.

Mary Louise Booth, born in 1831 in Yaphank, is probably its most celebrated resident. She was well known in publishing circles as the author of the first history of New York City and founding editor of *Harper's Bazar* magazine. She was also secretary of the first Women's Rights Convention, an active abolitionist, and a translator of over 40 books in seven languages. Her parents, William Chatfield Booth and Nancy Monsell, are from old Long Island families; the Booths come from Shelter Island and Southold, and the Monsells came from Middle Island and Bellport in the early days.

As the community grew and became more prosperous, the Suffolk County Almshouse was built in 1871 on Yaphank Avenue. Soon after, the Suffolk County Children's Home was built across the street. William Jones Weeks was the first superintendent of the almshouse, setting up daily routines and schedules that made it known as the best in the state.

By the turn of the 20th century, Yaphank was known as a bucolic summer destination, and several of the larger houses were then boardinghouses for visitors from the city, who were known as "summer strangers." They came out on the Long Island Railroad for the swimming, boating, and fishing on the lakes. All these activities were described in the *Yaphank Courier*, a summer newspaper.

The Yaphank Grange was organized in 1913 to encourage young people to stay on the farm. The grange was the center of community life with classes in agriculture, dance, and theater. As rumblings of World War I were heard, Camp Upton was established as an Army training camp for men from the tristate area. Young composer Irving Berlin was stationed there and put Yaphank on the map when he produced the show *Yip Yip Yaphank*. The musical went on to a short run on Broadway and was made into a film, *This Is the Army*, during World War II. After the war, Camp Upton became an important research facility called Brookhaven National Laboratory.

One can drive through Yaphank, still an unusual and beautiful rural community situated between the lakes, and quickly see its historic houses and traces of the past. In these pages, we hope that you will stop and visit to learn more about the people and places of Yaphank from years ago.

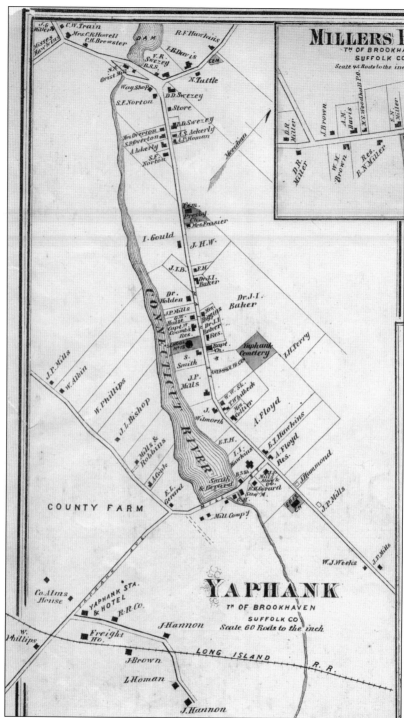

This 1873 Beers-Comstock map illustrates the layout of the hamlet of Yaphank as it was settled between the two mills and their millponds. Main Street developed parallel to the river between them, and its homes and shops populated the surrounding area. (Courtesy Yaphank Historical Society.)

One

EARLY MILL DAYS

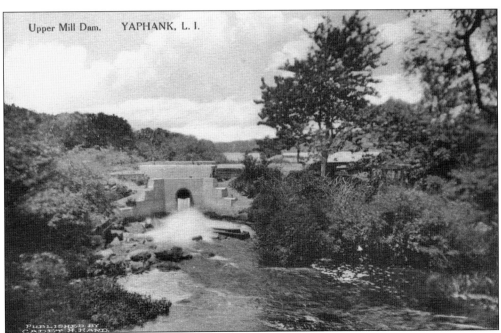

Millville, known for its natural beauty, was established on the banks of the Connecticut River in the early 18th century. By the mid-19th century, it had become a prosperous mill town named Yaphank. In the late 1700s, Christopher Swezey purchased Swezey's Sawmill (on the upper lake) from Capt. Robert Robinson. (Courtesy Edythe Davis.)

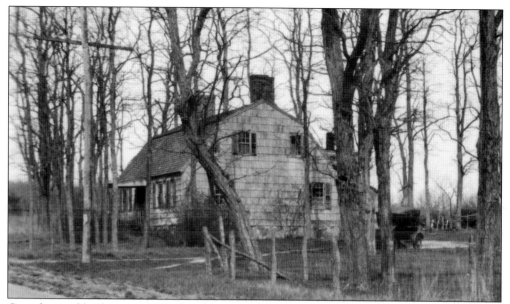

On a dirt road leading into Millville, Captain Robinson built a Dutch Colonial house across the road from the Connecticut River. This early house has the year "1726" chiseled into the stone foundation, marking this as the founding date of Millville. In 1739, he was granted permission by Brookhaven's town board to build a mill across from his dwelling. (Courtesy Longwood Public Library.)

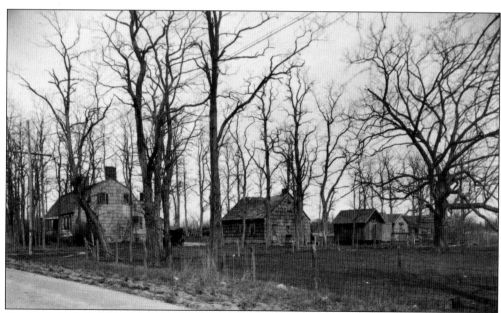

The Mills Tuthill farm stood near Swezey's Corner. Captain Robinson built it in 1726. It was later owned by Isaac Mills and then by veterinarian Nathaniel Tuthill. During a 1960s restoration, former owner Inez Mannino reported that an apparition, a man in black with sideburns, appeared several times saying, "Everything will be all right." (Courtesy Longwood Public Library.)

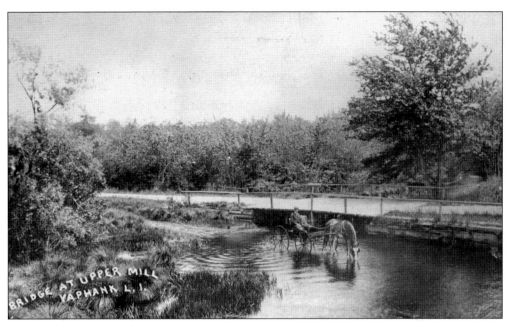

Approaching Swezey's Sawmill from the north and the west, wagons traveled along Mill Road, one of the earliest roads in the town, and across the "going over" to the mill. The expression is still used today by older residents of Yaphank as they go over the two bridges into town. (Courtesy Edythe Davis.)

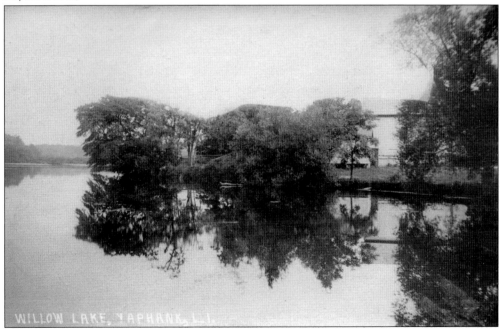

Swezey's Mill Pond became known as Willow Lake because of the willow trees that flourished there. L. Beecher Homan, in *Yaphank As It Is and Was and Its Prominent Men*, wrote, "As long as the waves murmur on the shores of Willow Lake and the groans of Swezey's Mill are wafted to the ears of the villagers, the Swezey name will remain in the annals of Yaphank history." (Courtesy Longwood Public Library.)

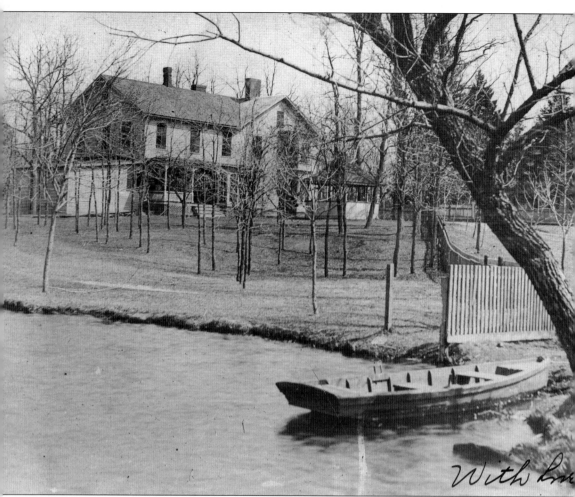

Van Rensselaer Swezey lived at the Swezey homestead on the east bank of the river, which was originally a small stone foundation structure dating from pre-Revolutionary times. In 1843, he added a Victorian addition with a porch facing Main Street. He was a staunch Presbyterian, and Sunday services were often held at his home when inclement weather prevented the villagers from traveling to the church on Middle Island. Many years later, his son Dr. Gilbert H. Swezey wrapped a long, white, winding picket fence around his property running down along Mill Road. The back lawn stretches to the Mill Pond, where a gazebo is situated, and it was there that a large lawn party was held in the afternoon and evening to celebrate his daughter Lillian's 16th birthday on July 17, 1890. It was the social event of the season. (Courtesy Longwood Public Library.)

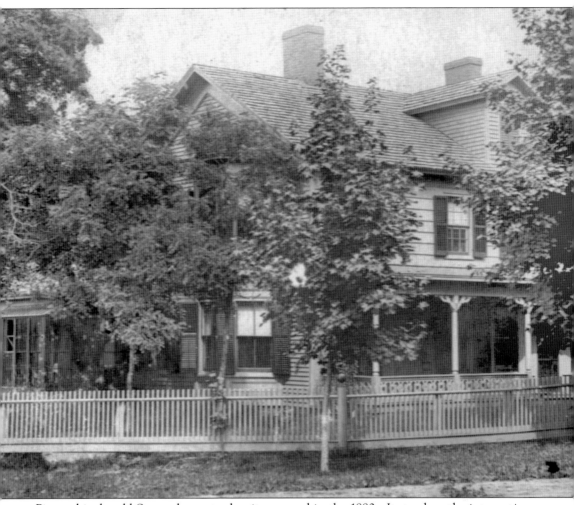

Pictured is the old Swezey homestead as it appeared in the 1880s. It stood on the intersection known as Swezey's Corner at the entrance to town. Dr. Gilbert Swezey, son of Van Rensselaer, raised eight children here. He had a medical practice in Brooklyn as well as in Yaphank. He rented land across the street from his property at the Tuthill Farm to raise purebred, registered cows and called it Walnut Farm Dairy. In 1891, he advertised in the *Yaphank Courier* his gilt-edged butter as a specialty, made by the "Cooley Creamer" process. His daughter Sarah E. Swezey also chose a career in medicine. In 1911, Dr. Sarah Swezey traveled to India and served at a Presbyterian mission northwest of Calcutta. While there, she met and eventually married H.T. Avey and returned to Yaphank. The house became known as the Swezey-Avey House, and she ran her practice from the residence for many years. After her death in 1963, the house was sold to the Town of Brookhaven and used by the community. (Courtesy Eleanor Davis Erhardt.)

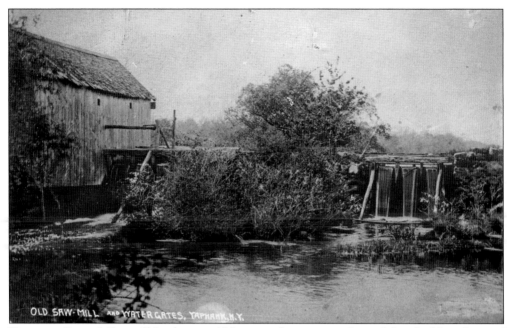

Known as Swezey's Sawmill for the next 100 years, it became popular with boatbuilders. Some of the sawn planks were chained underwater to "water-cure" them. Boatbuilders came to the mill with a pattern, cut the white oak, and sized it for stem sections and knees used in boatbuilding. (Courtesy Longwood Public Library.)

The Middle Island Yaphank Road was wooded, but it was well travelled, bringing residents from Ridge and Middle Island to shop in Yaphank. Besides the gristmills and sawmills, Yaphank had a printing shop, meat market, shoe shop, lumberyard, and a veterinary establishment. It was possible to spend a whole day in Yaphank shopping. (Courtesy of Edythe Davis.)

Daniel Downs Swezey built this house on Main Street soon after he bought out his brother's interest in the mills. He served on the Brookhaven Town Board for 32 years and ran the mills until his death in 1876. With both Swezey houses and the mill at this intersection, it became known as Swezey's Corner. (Courtesy David Overton Collection.)

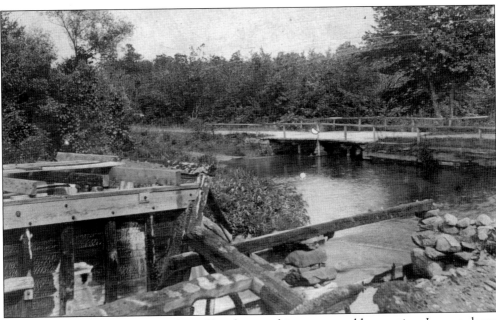

After the death of D.D. Swezey, the mill and its machinery were sold at auction. In accordance with the terms of the sale, the mill was moved to the other side of the river where it continued operation for another 34 years as the King and Edwards Mill. It burned down in 1914, and that was the beginning of the end of milling in Yaphank. (Courtesy Edythe Davis.)

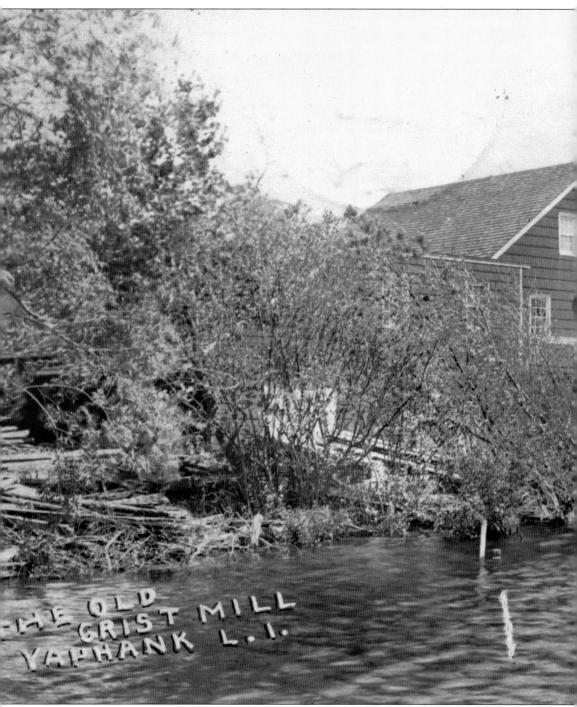

THE OLD GRIST MILL YAPHANK L. I.

Yaphank's other mill complex, built in 1762 farther south on the river, was the center of life in the community and established the other boundary of the village at the opposite end of Main Street. It was a typical family mill complex with mills, a residence, and related outbuildings. People from neighboring communities of Coram, Moriches, Middle Island, Bellport, and Ridge brought their

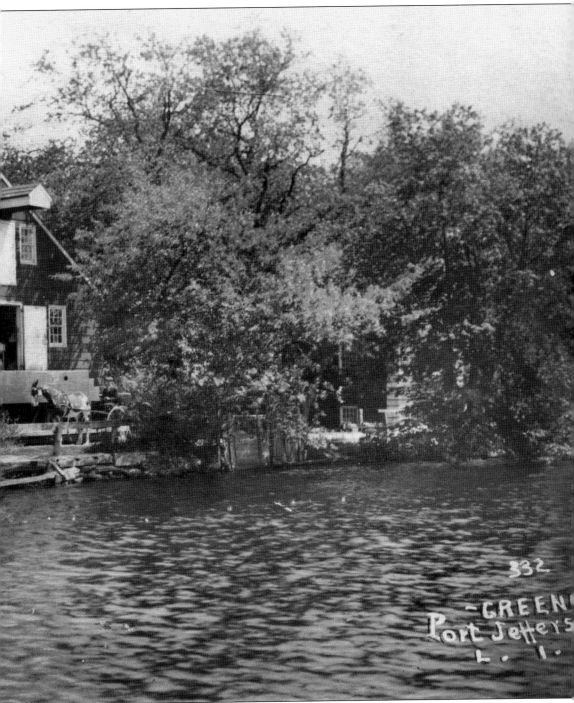

332
-GREEN
Port Jeffers
L. I.

grain to the gristmill and patronized the shops and businesses on Main Street. The sound of the millstones was a constant background hum in the village. When the mills were repaired, the millpond was drained and everything shut down, but the children had a field day with the stumps and large snapping turtles found at the bottom of the riverbed. (Courtesy Edythe Davis.)

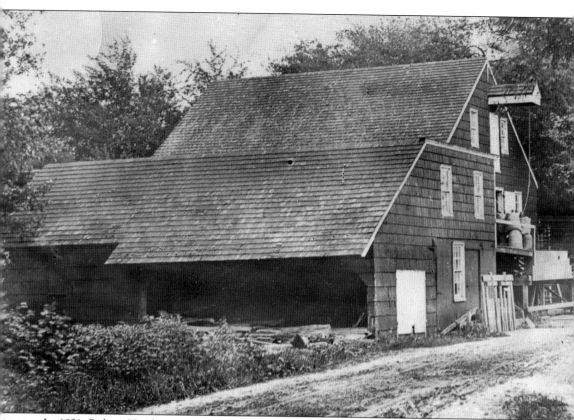

In 1821, Robert Hawkins, a wealthy farmer and landowner, bought the Homan Mills. He had come to Yaphank many years earlier from his family homestead in Setauket when he inherited his family's Yaphank land, which was part of a number of long lots that had been purchased from the Town of Brookhaven. He tore down the sawmill and built a larger mill. He raised his sister Martha's son, Robert Hawkins Gerard, in his own household and taught him the milling business. Known as Hawkins Gerard, he mastered the trade and eventually inherited the mills from his uncle, expanding the business even further and becoming a very successful businessman. He also established a large lumberyard, which was an indispensable convenience in the growing community. He was actually born in Fire Place in Brookhaven and married Fanny Hawkins, daughter of Rev. Nathaniel Hawkins. (Courtesy Edythe Davis.)

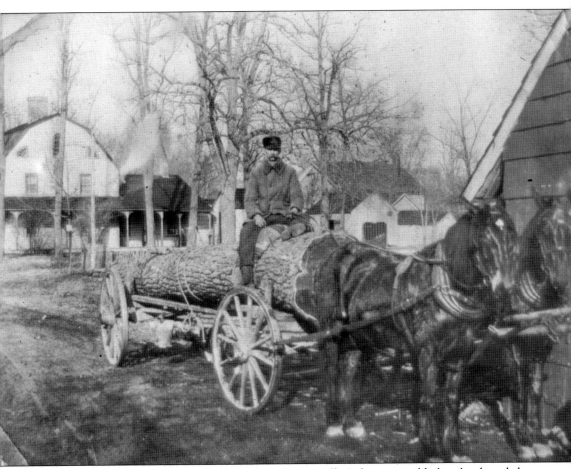

Large logs arrived by wagon to Hawkins Gerard's sawmill. A farmer would clear land, and the felled trees would be loaded onto wagons and brought to the mill. Logs could be sold, or one could pay to have the logs cut into planks for construction. Working at a sawmill was hard work, as the waterwheel only powered the saw. There was a lot of heavy lifting, since the logs had to be loaded and moved by hand to the saw. Having a sawmill in a community was a stimulus for growth, so having sawmills at both ends of town was a great boon to Yaphank's economy. All of the old houses standing in the historic district were built with lumber from Gerard's Mill or Swezey's Mill. Some of the milled lumber was marked with roman numerals for easy framing at the building site. Gerard's lumberyard sold mantels, newel posts, and balusters. Local men, some of whom were named Norton, Petty, and Davis, built the houses. (Courtesy David Overton Collection.)

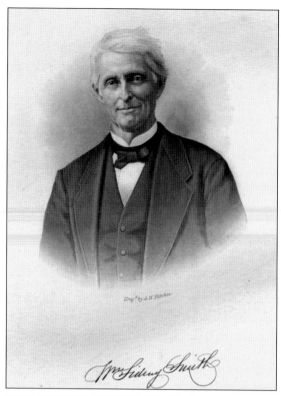

In 1859, Hawkins Gerard went into partnership with William Sidney Smith of the prominent Longwood Smith family and opened a woolen factory south of the sawmill and gristmill. Their intention was to ship their products across the country, as the Long Island Railroad had just opened up opportunities for expansion and distribution. The woolen factory was not profitable, however, and soon closed. (Courtesy Town of Brookhaven.)

The old red mill run by Hawkins Gerard was a sawmill and gristmill. Hawkins Gerard adopted his nephew Edward L. Gerard when the boy's father, a ship captain, was lost at sea. In 1881, E.L. Gerard was permitted by his uncle Hawkins Gerard to take over the lumberyard at the mill. He was successful in business and later inherited all the mills. (Courtesy Yaphank Historical Society.)

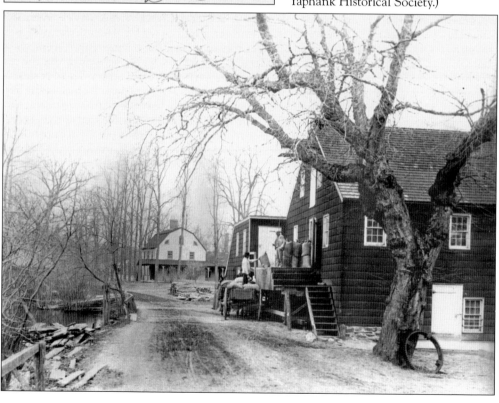

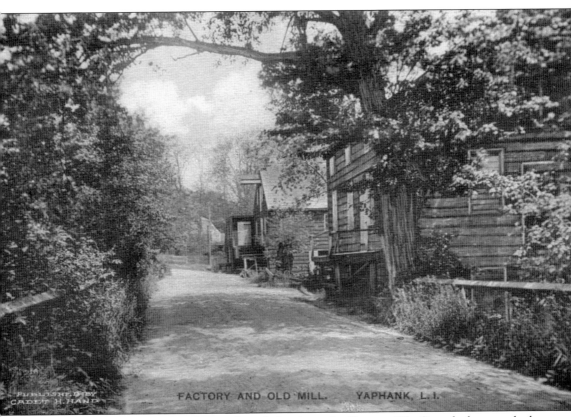

FACTORY AND OLD MILL. YAPHANK, L. I.

Cadet Hand, who married Catherine Gerard, daughter of mill owner E.L. Gerard, photographed this picturesque scene of the mill and woolen factory on a beautiful summer day. A scenic-view photographer, he captured many homes, businesses, and lake views of Yaphank. It was the era of penny-postcard popularity, and Yaphank had many worthy settings for him. These postcards were very collectible for photo albums, and making scrapbooks was a popular pastime of the day, especially for the summer visitors who frequented Yaphank. The lake views, flower gardens, and boardinghouses were popular selections for them and could be easily purchased at the general stores on Main Street. Cadet Hand always signed his photographs on the front, unlike other local photographers, and postcard collectors seek after his signature today. (Courtesy Edythe Davis.)

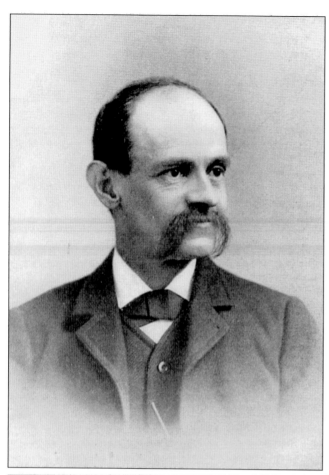

Edward L. Gerard was very popular in the village. He played the organ on Sundays at the Presbyterian Church and was superintendent at the Suffolk County Almshouse. On the day of his funeral in 1899, business in the village was suspended and the entire community joined in tribute to his life. He is buried in the Yaphank Cemetery. (Courtesy *History of Long Island*.)

Gerard's wife, Agnes, continued operating the mills after his death. By the turn of the 20th century, however, hydroelectric plants were replacing most water mills, and small family complexes were disappearing. The millstones remained as a reminder of Yaphank's past. (Courtesy Longwood Public Library.)

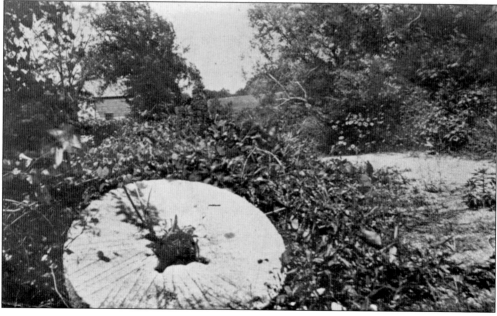

After Edward L. Gerard's death in 1899, Agnes Gerard tried to collect all outstanding debts. Money was slow to be repaid. Eventually Agnes tried to mortgage the mills, but she was unsuccessful due to poor business conditions. (Courtesy Yaphank Historial Society.)

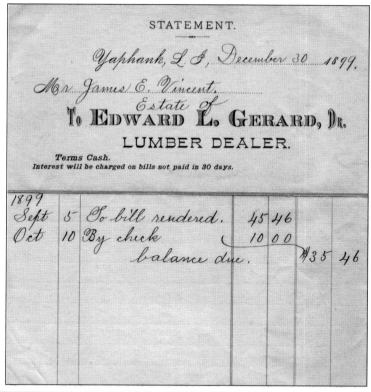

STATEMENT.

Yaphank, L. I., December 30 1899.

Mr. James E. Vincent.

Estate of

To EDWARD L. GERARD, Jr.

LUMBER DEALER.

Terms Cash.
Interest will be charged on bills not paid in 30 days.

1899						
Sept	5	To bill rendered.	45	46		
Oct	10	By check			10	00
		balance due.			$35	46

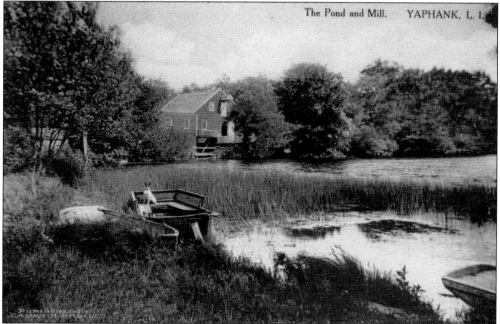

The Pond and Mill. YAPHANK, L. I.

As the mill business declined and Agnes Gerard needed to supplement her income, like her neighbors, she took in summer boarders, or "summer strangers," as they were called at the time. In 1901, she advertised in the *Brooklyn Eagle* for boarders, offering swimming, fishing, and boating on her millpond. (Courtesy Edythe Davis.)

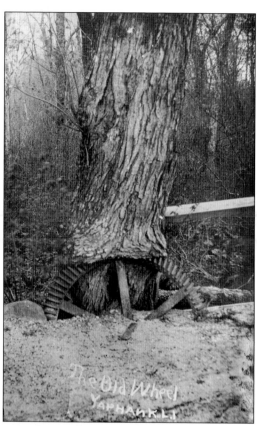

Gerard Mills burned down in 1919, changing a way of life in the village forever. This old mill gear stood near the "going over" to Gerard's Mill, which many thought symbolized the demise of the old water mills. With both the Swezey Sawmill and the Gerard Mills now gone, the village was unnaturally quiet. (Courtesy Edythe Davis.)

Trying to keep the milling industry alive in Yaphank, William and Gertrude Schroeder built this small sawmill in 1919 on the site of the old sawmill and ran it for a short time, but the mill was unsuccessful and closed in 1920. The sawmill provided a last gasp for milling in Yaphank. (Courtesy Kenneth B. Hard.)

In 1922, Anson W. Hard, the last member of the Suffolk Club, purchased the Gerard Mills property at auction for $7,000 to use with the club property for shooting. It was known as the Hard Estate. The Homan Gerard House was built in 1790 and is a fine example of 18th-century architecture in the area. Suffolk County Historic Services and the Yaphank Historical Society are currently restoring it. (Courtesy Longwood Public Library.)

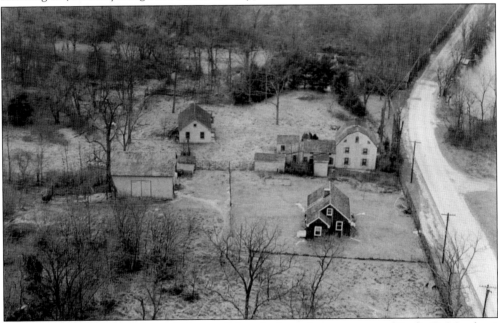

In 1932, Anson Hard and his wife divorced, but she kept the property, and Leslie R. Marchant built a gamekeeper's cottage on it in 1941. Their son inherited the property and kept it until Suffolk County bought it for Southaven Park. It now anchors Yaphank's historic district with the river running through it at Main Street and Yaphank Avenue. This aerial photograph was taken around 1945. (Courtesy Kenneth B. Hard.)

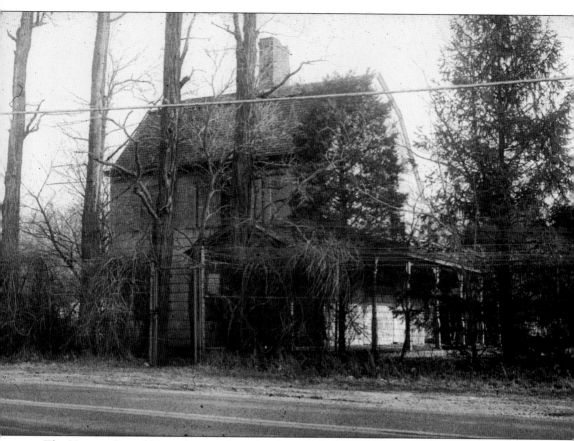

The Homan-Gerard House has not been lived in since the 1940s. It was sealed up and has been slated for restoration since the 1970s. A roof was installed, and the house has been boarded up and secured, waiting for restoration funding. In the National Register of Historic Places since 1988, it is an important early structure in Yaphank's history. Now undergoing extensive restoration by Suffolk County Historic Services and the Yaphank Historical Society, it will be an integral part of the historic district, which has been established at this intersection of Main Street and Yaphank Avenue on the river. Considered one of the oldest and most important examples of 18th-century architecture on Long Island, the Homan-Gerard House has Federal-style windows, doors, fanlights, and fireplace mantels still intact, but the main stairway has been removed and the condition of the house is in jeopardy. The summer kitchen is still attached, but some of the barns and outbuildings have collapsed. This important and long-overdue project is the final property to be restored in the historic district. (Courtesy Town of Brookhaven.)

Two

"LOVE TO OUR COUNTRY"

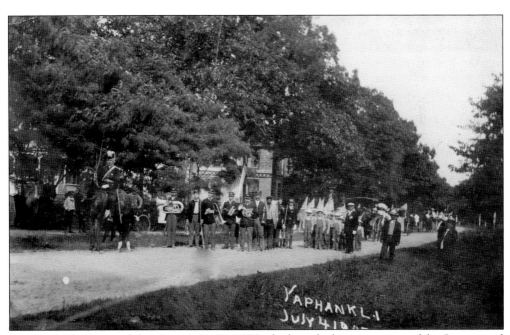

Many in Millville signed the "Association" in 1775, which made them supporters of the Continental Congress. They did "associate under all the Ties of Religion, Honor, and Love to our Country" and were known as patriots. During the Civil War, many of Yaphank's young men enlisted, and Yaphank was grateful to those who served. Veterans are honored in annual Fourth of July parades and celebrations. (Courtesy Edythe Davis.)

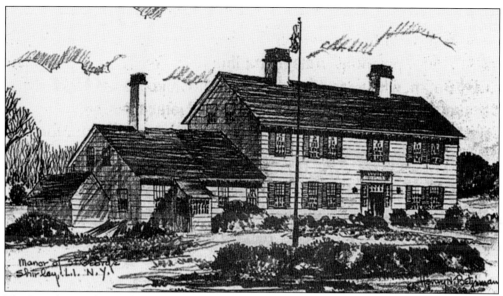

The British won the Battle of Long Island in 1776 and occupied it until 1783. Villagers were forced to sign an Oath to the Crown or lose their farms and livestock. Those patriots who continued to fight had to flee Long Island. Judge William Smith, a patriot leader, fled to Connecticut, and his Manor of St. George at nearby Mastic was occupied by British forces. (Courtesy the Manor of St. George.)

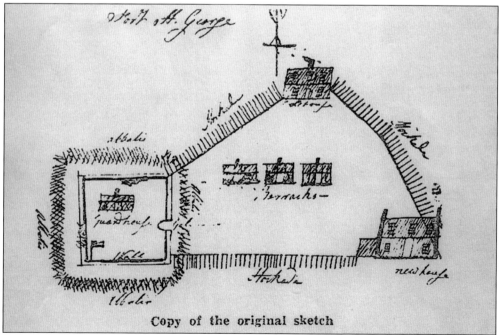

Copy of the original sketch

During the Revolutionary War, the British occupied the Manor of St. George and built a fort. Patriot William Chatfield Booth, who had been overseer there, sketched this map and sent it to Maj. Benjamin Tallmadge to aid in his plans to capture the fort. Tallmadge organized a spy ring to relay information to George Washington on Loyalist activities around New York City and Long Island. (Courtesy Town of Brookhaven.)

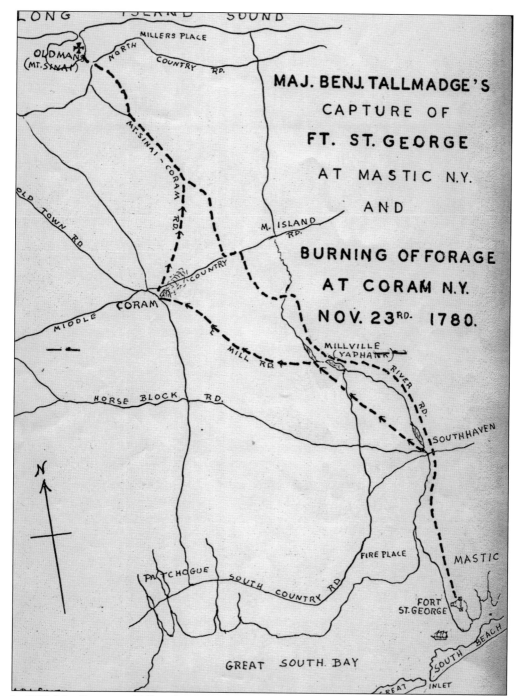

In 1780, Maj. Benjamin Tallmadge came from Connecticut, landed at Mount Sinai, and marched 21 miles across Long Island, passing through Millville, to capture Fort St. George. The Benjamin Tallmadge Historic Trail marks the course of the raid, the capture of the fort, and the burning of the hay at Coram. (Courtesy Town of Brookhaven.)

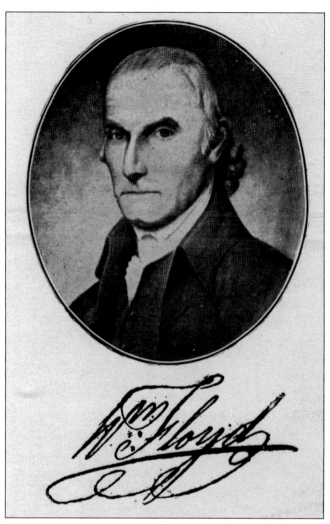

William Floyd, a patriot, was a delegate to the Continental Congress and a signer of the Declaration of Independence. General Floyd led the Suffolk County militia and had to flee Long Island when his estate was occupied by the Tories. He went to Connecticut with his family, as did most of his patriot friends on the east end of Long Island. (Courtesy *Refugees of 1776 from Long Island to Connecticut.*)

The William Floyd House at Mastic, built in the 1720s, was on 613 acres. Before the Revolutionary War, William Phillips of Millville was overseer and surveyor of the William Floyd estate and plantation at Mastic. Capt. William Phillips of Millville served under Floyd during the war. (Courtesy Fire Island National Seashore No. 18945.)

This land deed signed by William Floyd and his wife, Johanna, conveys two parcels to William Phillips. On June 10, 1779, Capt. William Phillips was granted liberty to go to Long Island to regain certain property belonging to General Floyd. In gratitude for this service, Floyd awarded Captain Phillips this land for £20. It remained in the Phillips family until 1941. (Courtesy Paula and Dana Bianca.)

A site on the Benjamin Tallmadge Historic Trail, the William Phillips House is on Yaphank Middle Island Road. Captain Phillips was a patriot serving under Gen. William Floyd. Major Tallmadge watered his horses and rested his men on the banks of the Carmans River behind this house and continued on to raid Fort St. George. He was elected and served as Brookhaven town supervisor from 1795 to 1797. (Courtesy Town of Brookhaven.)

The musket purportedly used by William Phillips during the Revolutionary War hangs below the mantel in the keeping room of the Phillips House. This is where the muskets and rifles were kept in the early days, ready for action, in most New England houses. The wood mantel and open hearth with a baking oven on the left were typical of this period. (Courtesy Yaphank Historical Society.)

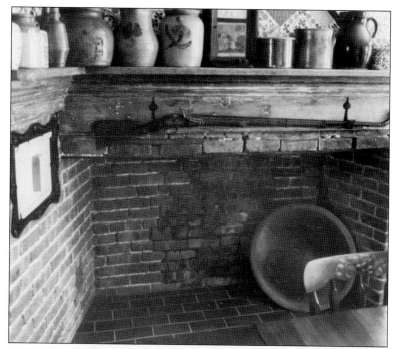

Arthur W. Phillips was the youngest son of Hannah and Philetus Phillips. He grew up on their 300-acre farm, and as a boy, he cut thousands of cords of wood, which were shipped by rail from Yaphank Station. By 1900, he had started a profitable business selling harvesting machinery. He is pictured here with his wife, Bertha, and their young daughter. (Courtesy Yaphank Historical Society.)

Descendants of the influential Hawkins family are pictured above. From left to right, they are (first row) Robert Finley Hawkins, great grandmother Nancy Hawkins, great grandmother Eliza Norton, and Gerard Hawkins; (second row) grandmother Elizabeth Hawkins and grandmother Caroline Amanda Shaw. This c. 1900 photograph was taken in the front yard of the Robert Finley Hawkins House to honor the four grandmothers in the family, all of them descendants of Yaphank's early settlers. (Courtesy Town of Brookhaven.)

The Hawkins family was known for their patriotism. At the Hawkins family cemetery, an historic marker reads, "In this final resting place, are buried Revolutionary War Patriots." Those listed are Samuel Conklin, Robert Hawkins, Zopher Hawkins, Joseph Homan, Oliver Homan, Joseph Tuthill, Josiah Hallock, and Gilead Mills. (Courtesy Eugene Dooley.)

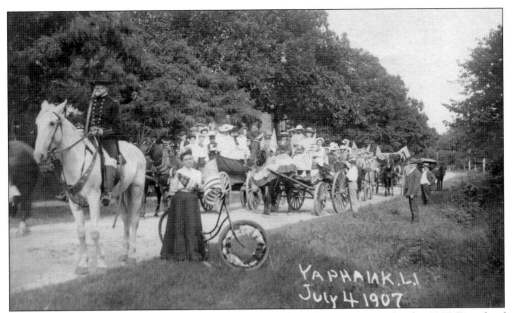

Colonel Marvin, a Civil War veteran, is pictured leading the procession for the 1907 Fourth of July parade. Clara Weeks stands with her decorated bicycle in the foreground as villagers line up in their bunting-swagged wagons and carriages with their American flags to proceed down Main Street. (Courtesy Edythe Davis.)

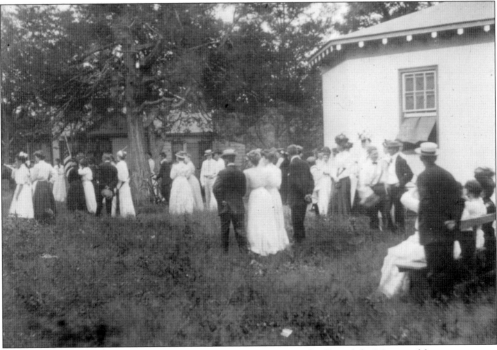

The octagon schoolhouse was at the center of the village and village life. Many public events were held there, such as plays, recitals, and performances. All parades chose it as a final destination. This is a Fourth of July celebration where the crowd, dressed in its finest, awaits the festivities. (Courtesy Gary Ralph.)

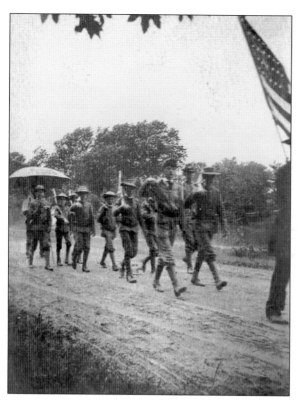

During the 1908 Fourth of July parade, these young cadets made a call of respect to Civil War veteran Smith W. Higgins. Higgins was given a salute, and the band played the "Star Spangled Banner," which he greatly enjoyed, as he had been in the US Signal Corps during the Civil War. He died 16 days later. (Courtesy Longwood Public Library.)

As illustrated on this 1908 postcard, at the end of the day all that remained was the red, white, and blue arch on Mill Road by the milldam. All over town, bicycles, boats, porches, and fences were decorated with patriotic buntings and flags in honor of the occasion. (Courtesy Longwood Public Library.)

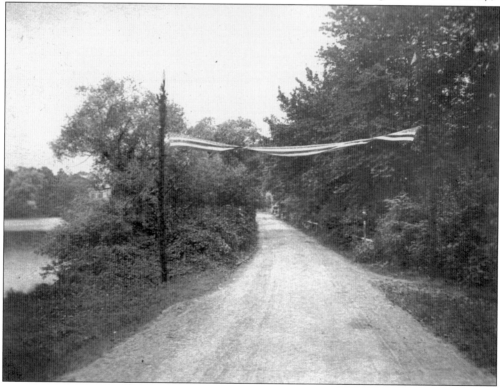

Three

THE WEEKS
FAMILY LEGACY

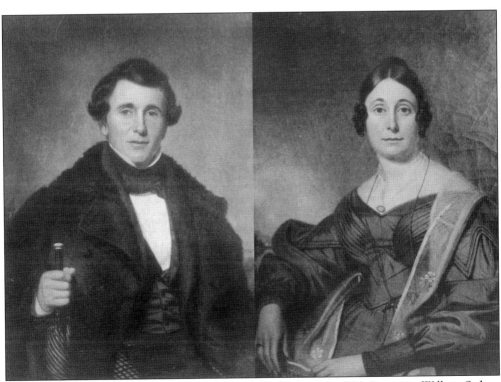

Yaphank's most important family, the Weeks, settled in Yaphank in 1828. Portraitist William Sydney Mount was commissioned to paint James Huggins Weeks and his wife, Susan Maria, in 1838. He purchased 9,000 acres of land from his brother-in-law William Sidney Smith and went on to make his fortune selling cordwood in New York City. (Courtesy of Robert and Elizabeth Martino.)

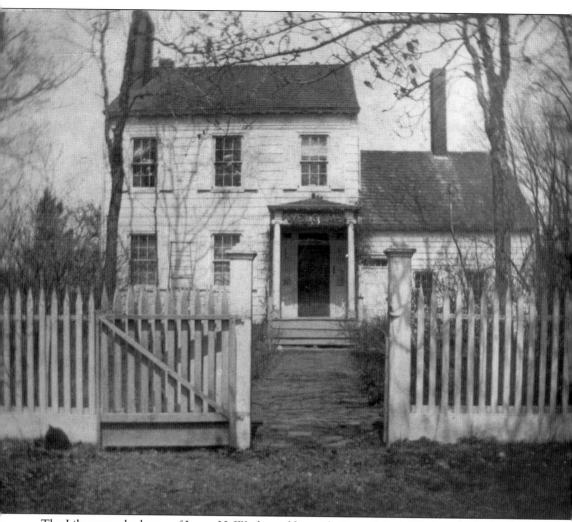

The Lilacs was the home of James H. Weeks and his wife, Susan Maria Weeks, which they built in 1828 when they moved to Millville from Oyster Bay. An elegant country home for its time, the Weeks family frequently entertained her family, the William Sidney Smiths of nearby Longwood Estate, as well as his business associates from New York City. After the death of James H. Weeks in 1879, their granddaughter Clara came across the street from The Octagon House to live at the Weeks homestead to take care of her grandmother. Clara never married and inherited the house when Susan Maria died in 1888. She then added a second story and took in boarders in the 1890s. She was very active in community and church affairs, and The Lilacs was her headquarters. (Courtesy Longwood Public Library.)

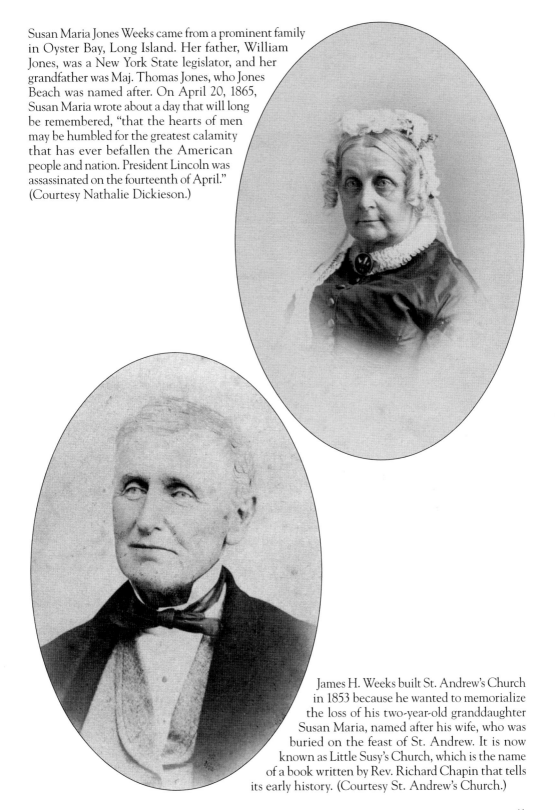

Susan Maria Jones Weeks came from a prominent family in Oyster Bay, Long Island. Her father, William Jones, was a New York State legislator, and her grandfather was Maj. Thomas Jones, who Jones Beach was named after. On April 20, 1865, Susan Maria wrote about a day that will long be remembered, "that the hearts of men may be humbled for the greatest calamity that has ever befallen the American people and nation. President Lincoln was assassinated on the fourteenth of April." (Courtesy Nathalie Dickieson.)

James H. Weeks built St. Andrew's Church in 1853 because he wanted to memorialize the loss of his two-year-old granddaughter Susan Maria, named after his wife, who was buried on the feast of St. Andrew. It is now known as Little Susy's Church, which is the name of a book written by Rev. Richard Chapin that tells its early history. (Courtesy St. Andrew's Church.)

William Jones Weeks (1821–1897) was the only son of James and Susan Maria. He graduated from Yale in 1844 and is credited by Yale for starting the first boat club, which was the forerunner of the Yale Navy. After Yale, Weeks returned to Millville to practice agriculture, horticulture, and surveying. L. Beecher Homan credits him with suggesting the name Yaphank when the village of Millville was renamed. He was a Renaissance man, forward thinking and community minded, who brought the newest ideas in agriculture and architecture to this small hamlet. Well respected for his intelligence and scientific knowledge, his endeavors have made a lasting contribution to the history of Yaphank. (Courtesy of Robert and Elizabeth Martino.)

Weeks was always working on new ideas to improve daily life, even in his early years as a student. When restricted to reading and studying by daylight, he invented a lamp that illuminated a desk for two students, which was adjustable and cost saving. He kept journals on his inventions and explorations. From age 30 until his death, he wrote a diary, called *Weeks Diaries*. (Courtesy *Yale Alumni Weekly*.)

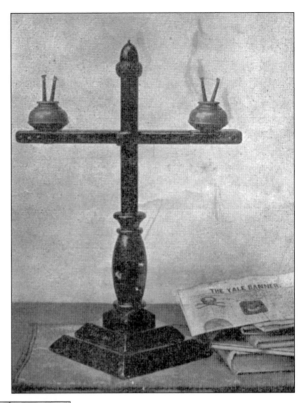

"Perhaps a literal interpretation of the *lux* in the Yale shield, more likely as a shrewd method of conquering necessity, William Jones Week, '44, built a remarkable lamp in his undergraduate days. So cleverly did he fashion it, that many modern student lamps have followed its adjustability and its simplicity of line." His family donated it to the Yale Library. (Courtesy the *Yale Alumni Weekly*, January 6, 1928.)

43

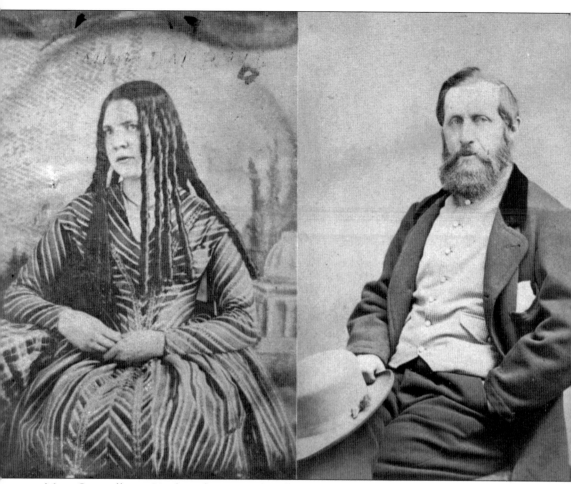

Mary Croswell was 21 when she married William J. Weeks on January 28, 1848, at Gilboa, Schoharie County. Her mother was Hannah Winslow Paige, a descendant of Kenelm Winslow, who came to America on the second voyage of the *Mayflower*. Mary was a quiet girl who favored reading and the study of botany, as did her new husband. He also spent time researching and documenting wildlife and fowl and taught himself taxidermy, preserving specimens of local birds for the Suffolk County Agricultural Society. His snowy owl and wood duck are in the collection of the Yaphank Historical Society. William and Mary had their first child, Susan Maria, at the end of 1848. He brought his designing mind into his family life as well, creating and crafting ergonomic baby shoes for his children in his workshop at The Octagon House. (Courtesy Elizabeth and Robert Martino.)

William J. Weeks built an octagon house on East Main Street across from his family home, The Lilacs, on land given to him by his father for his wedding. He writes in *A Weeks Family Record*, dated November 23, 1849, "Mary, Susy and I take up our abode in our new house, much pleased, though the house is unfinished. I am designing to finish it myself during the winter ensuing." He was very hands-on and built small additions to the house as more space was needed. Very innovative for its time, it was a destination for many visitors and the prototype for the octagonal school. Originally skeptical, the villagers were later proud of his forward-thinking designs. After his studies at Yale, he was employed as a surveyor of land, and his signature is on many maps, deeds, and drawings of properties in Suffolk County. (Courtesy Nathalie Dickieson.)

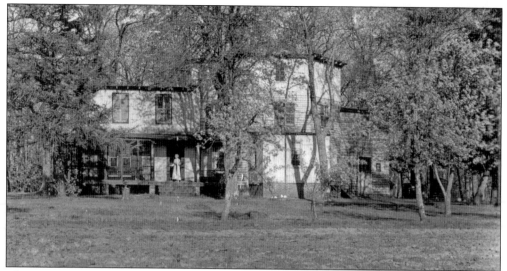

The Octagon House: A Home For All, by Orson Squire Fowler, was published in 1848. Fowler claimed, "Octagons were cheaper to build, allowed additional living space, received more natural light, were easier to heat, and remained cooler in summer." Octagon building design became popular on the eastern seaboard and was especially sought after in New York State. (Courtesy Nathalie Dickieson.)

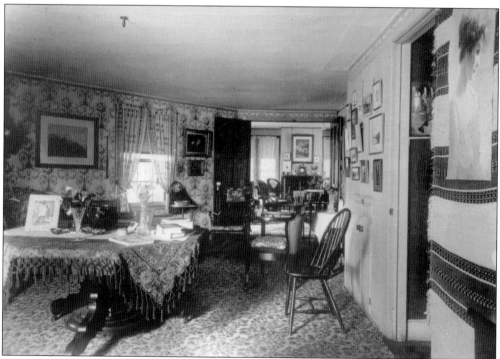

Nathalie Dickieson describes her grandfather Weeks's Octagon House: "Grandfather's was a strange and wonderful house. There were no hallways, only stairs. There was no central heat, just a fireplace, and two wood stoves." The first floor had a kitchen and dining room divided by cupboards. The second floor had six bedrooms, and there was a third floor attic for storage. (Courtesy of Nathalie Dickieson.)

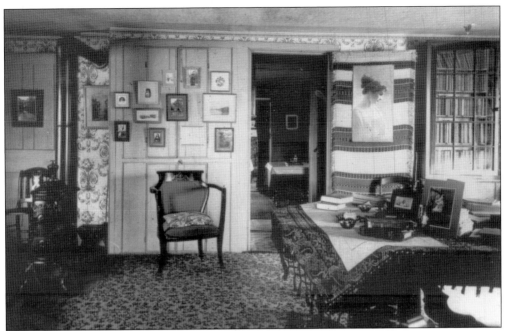

The sitting room of the octagon was where William J. Weeks kept abreast of his correspondence, drew his surveyor maps, and kept the accounts for the Suffolk County Agricultural Society, where he served as treasurer. It was here that he designed the Octagon School, which he built when he was school superintendent. (Courtesy Nathalie Dickieson.)

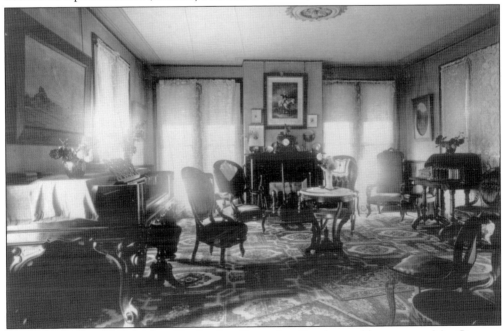

The piano in the parlor was played by daughter Susan Amelia, who would accompany Mrs. Carman, her daughter Mabel Carman, and neighbor Mattie Collyer as they practiced hymns for Sunday's church service. Susan's diary also tells of sitting in the parlor, which was in a rectangular addition to the octagon, where they spent evenings telling fortunes with cards. (Courtesy Nathalie Dickieson.)

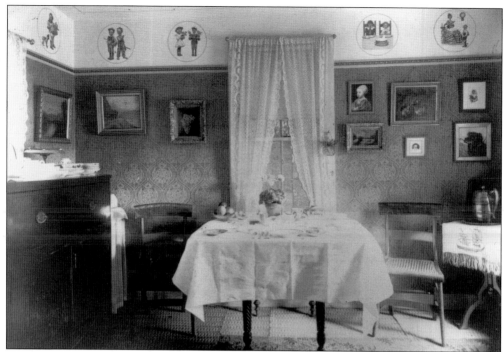

The breakfast room was presided over by Mary Weeks and her housekeeper Eliza, who dealt with the butcher, the egg man, and Mrs. Fields, who came to collect the laundry. Together, Mary and Eliza would fill jars with strained honey, cook apple jelly, and bake pound cake. (Courtesy Nathalie Dickieson.)

Flowers lined the carriage road in front of The Octagon House. In her diary, Susan Amelia tells of canning pears, peeling quince, and storing bushels of apples for winter. William Weeks also grew grapes and won many prizes for his varieties. All of the fruit was harvested from the orchard on their estate. (Courtesy Nathalie Dickieson.)

Mary Croswell Weeks is pictured here with her second child, Archibald Crosswell Weeks, who attended Cornell University. Cornell credits Archie and his roommate, Wilmott Smith, with writing the lyrics to their alma mater that are still used today. After graduation, Archie joined the law firm of Hornblower and Weeks in New York. In 1890, the *Brooklyn Eagle* listed him as secretary, Department of Entymology, at the Brooklyn Institute. (Courtesy Nathalie Dickieson.)

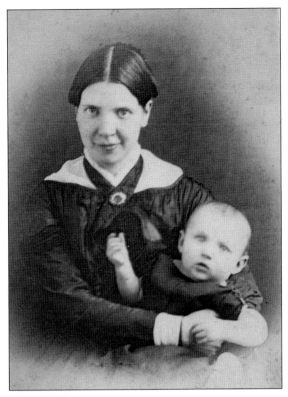

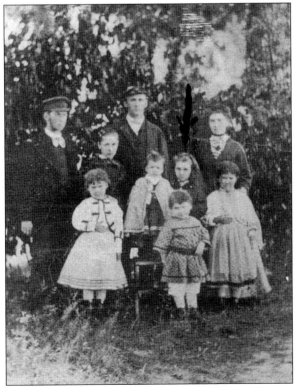

William and Mary Weeks had 12 children, six boys and six girls. The nine children in the photograph remained firmly attached to their Yaphank roots throughout their lives. As adults, they came to Yaphank each summer and divided their stay between their parents' Octagon House and The Lilacs, their grandparents' home. (Courtesy St. Andrew's Church.)

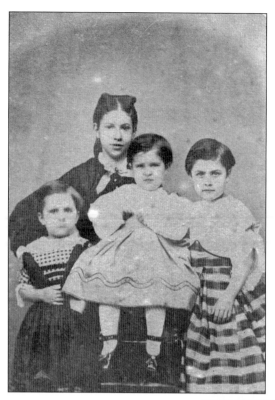

The Weeks girls are, from left to right, Julia Elizabeth, Susan Amelia, Clara Winslow, and Harriet Paige. Julia married Joseph Lawles and moved to Brooklyn, and Susan later married Will Gerard. Clara never married and lived at The Lilacs, taking care of her grandmother, and Harriet married Charles Hawkins. (Courtesy of St Andrew's Church.)

Francis William Weeks was 17 in 1884 when he cut his leg chopping wood. His father chronicled his death in *A Weeks Family Record*: "Francis was taken about 2 weeks previous to his death. Hypodermic injections of morphine induced a sleep from which he never awakened . . . he was interred in the family ground in the bloom of his youth." (Courtesy Richard Chapin.)

Upon the death of her mother, Mary Croswell Weeks, in 1883, Susan Amelia took over the household duties. In her diary, she recorded the chores she did along with everyday happenings. Each day, she noted the weather, such as "clear bright day" or "cold north wind." Her days were filled with baking and cooking. She served chicken, beef, and mutton along with pudding, molasses cakes, and ladyfingers, according to her diary. In 1893, Susan Amelia married Will Gerard and moved to Brooklyn. They were very active in their church choir and enjoyed their common interest in music. Her 1895 diary reflects how close she remained to her sisters. That year, she went by train to Yaphank before Thanksgiving and stayed at The Octagon House until after New Years, which was the custom of the time. Many wives and children went out to the country for holidays, and husbands came out from the city on weekends. (Courtesy St. Andrew's Church.)

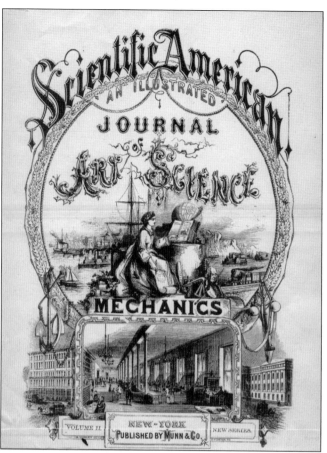

Being interested in the keeping of bees, William J. Weeks wrote a paper on how the honey bee is able to construct hexagonal cells, which was published in the May 1860 *Scientific American*. He also provided many fine specimens of native wildlife for the Long Island Historical Society. (Courtesy *Scientific American*.)

In the summer of 1878, a *Patchogue Advance* news article reported on William Weeks picking his cranberries: "Years ago he conceived of the idea of turning low swampy land to account and while wise-acres declared it nonsense, and whispered together, Mr. Weeks pushed his enterprise and today produces the best cranberries in the county." (Courtesy Longwood Public Library.)

The cornfield was planted west of The Octagon House, where William Weeks cultivated strawberries and grapes and showed at the Suffolk County Agricultural Fair. An 1865 article notes, "WJ Weeks received premiums for greatest varieties of grapes and 4 cases of native insects." The November 6, 1890, edition of the *Yaphank Courier* lists the prizes taken at the fair: W.J. Weeks, cranberries, first and second; and grapes, second. (Courtesy Nathalie Dickieson.)

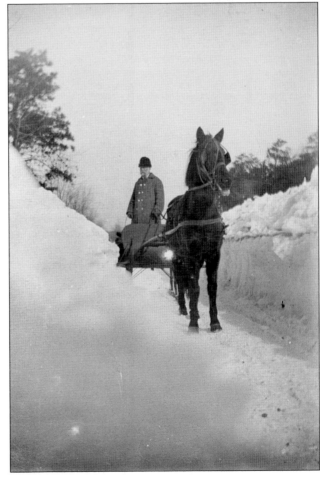

William J. Weeks pauses on Yaphank Avenue with Nellie, his horse. Weeks loved the outdoors. He wrote in his diary, "Went to Wampmissic this morning by sleigh and took an account to wood cut by Ackerly, about 80 cords." He owned 3,100 acres of woodland at Wampmissic (Indian word for place of chestnuts) and shipped the wood to New York City for fuel and home construction. (Courtesy Elizabeth and Robert Martino.)

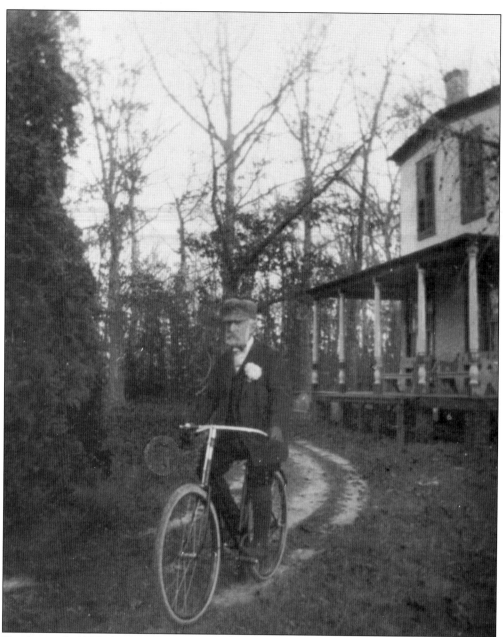

On August 2, 1896, the *Brooklyn Eagle* reported, "A new bicycle club has just been formed, the 'Yaphank Bicycle Club.' The object is to build a bicycle path on Yaphank Avenue from South Country Rd to Yaphank, a distance of about 3 miles." Its officers were W.J. Weeks, the champion septuagenarian cyclist and skater, president; W.J. Ashton, vice president; Miss Floyd, treasurer; and J.H. Lawless, secretary. Weeks was a fitness fanatic, who continued to challenge himself with exercise into his late years. He only drank water and abstained from alcohol and tobacco his whole life. He was also a great walker and would stride long distances for meetings and while visiting neighboring estates, such as Longwood. As an undergraduate at Yale, he walked from New Haven to Boston carrying a 12-pound valise as an exercise in physical discipline. (Courtesy Laura Irwin.)

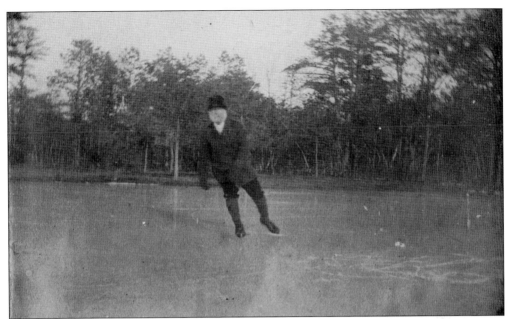

In the *History of Long Island*, Pelletreau writes, "From his youth up to the last year of his life, he was an enthusiastic skater, cutting exceeding grace and dexterity and writing both capitals and small letters singly or in combination." Weeks was known for skating the Lord's Prayer and Ten Commandments on the ice with engraving-like accuracy. (Courtesy St. Andrew's Church.)

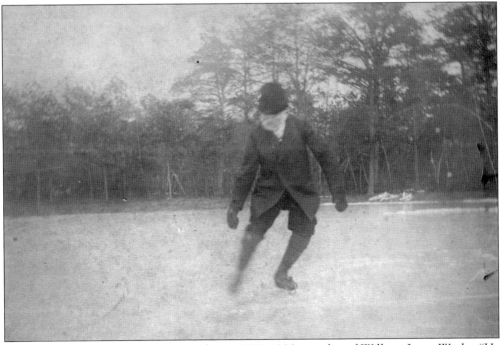

His obituary in *Obituaries of Yale Graduates 1890–1900* says this of William Jones Weeks: "He retained through life extraordinary physical vigor and after the age of 75, was still an expert in figure skating, bicycling and other outdoor sports." William Jones Weeks died of stomach cancer in September 1897. (Courtesy Laura Irwin.)

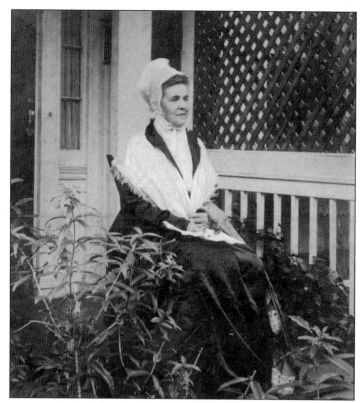

Clara Winslow Weeks was a familiar sight and was well loved and respected in the village. Gus Neuss remembered her wearing old-fashioned clothes and peddling down Main Street on a bicycle. She ran church fairs and Sunday school gatherings at The Lilacs. She never married, but she raised four children who she took in from the Suffolk County Children's Home, where she served on the board. (Courtesy Richard Chapin.)

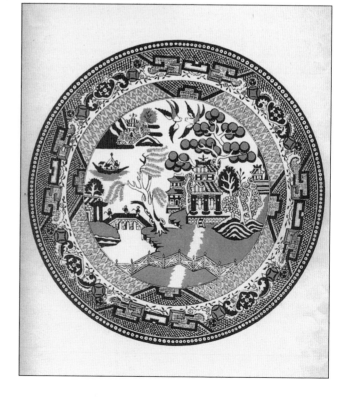

A 1913 review in the *New York Times* said, "In a pretty little book, called '*Story of a China Plate*,' Clara Winslow Weeks gives an explanation of the picture everyone is familiar with who has had the good fortune to live in a house that is the abiding place of a set of china of the willow pattern." A facsimile edition is still in print today. (Courtesy Yaphank Historical Society.)

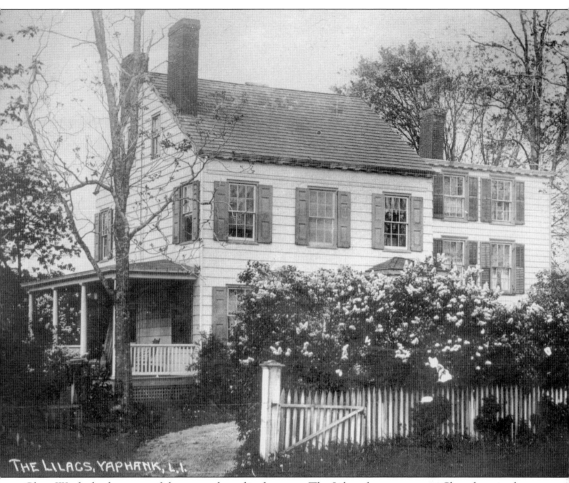

THE LILACS, YAPHANK, L.I.

Clara Weeks had a successful summer boardinghouse at The Lilacs for many years. She advertised, "summer boarding establishment, 60.6 miles from NYC, $2.18 a day, with a capacity of 10 guests." This message for guests hung in The Lilacs: "In this house you may meet those not of your sort. They may differ from you in nationality, birth, position, possessions, education, or affinity, but we are maintaining here a small part of the world's great democracy." As an entrepreneurial woman at the turn of the 20th century, she also created a business giving $500 mortgages at six percent interest for $10 a month. Her book on the willow china pattern was sold at local events for 50¢, and with her love of entertaining, the arts, and music, The Lilacs was a destination for family and friends for many years. (Courtesy Nathalie Dickieson.)

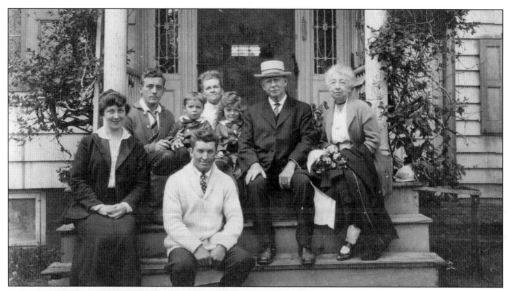

Clara was known for her sense of humor, and her niece Nathalie Dickieson can remember a time when summer guests were having difficulty cutting breakfast pancakes. There were gales of laughter when they discovered small rounds of felt that Clara put between the pancakes as a joke. She died suddenly in 1929. Her good deeds and keen sense of humor were sorely missed. (Courtesy St. Andrew's Church.)

Clara Weeks loved a good party. She created the Friendly Club and handed out membership cards, promising "social games, conversation, music, etc." Her father wrote of a party when she rolled up the rugs and fiddlers from Bellport played until dawn. Here, Harry Weeks, Miss McConnell, and David Hesselberg enjoy an afternoon at The Lilacs. (Courtesy St Andrew's Church.)

The 1935 *Patchogue Advance* wrote, "Flowers and presents were heaped upon Mr. & Mrs. Joseph H. Lawless at their home, The Lilacs, Yaphank, last Monday, where friends and relatives gathered to honor the couple's golden wedding anniversary." Julia Weeks Lawless and her husband, Joseph, were the last to live at The Lilacs. It burned to the ground in 1941. (Courtesy Robert and Elizabeth Martino.)

Dudley Lawless was the son of Joseph and Julia Weeks Lawless. He and his sister Natalie spent many summers with their aunt Clara Weeks while their parents traveled abroad. Dudley passed away as a young man, but his sister Natalie lived a long life and shared her many happy memories in Yaphank in her writings. (Courtesy Nathalie Dickieson.)

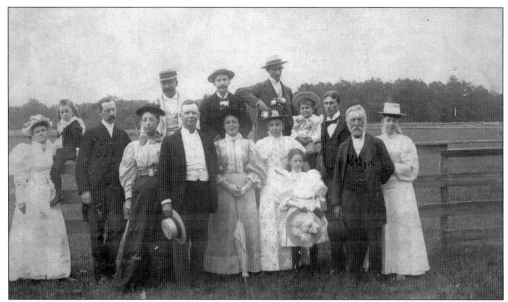

The Weeks family is pictured in 1895. From left to right, they are (standing) Clara Weeks, Reverend Petty, Antoinette Weeks, James Weeks, Saidee (Reginald's friend), Julia Lawless, Natalie Lawless, Reverend Thompson, William Weeks, and Susan Amelia Gerard; (sitting on fence) Harry Davis, Will Gerard, Reginald Weeks, Joseph Lawless, and Dudley Lawless. (Courtesy Nathalie Dickieson.)

Reginald Constantine Weeks left Yaphank to live and work in New York City. He, too, remained close to the family by spending weekends at The Octagon House. He eventually inherited the house and property. After his death in 1936, the Weeks estate was sold and became a part of the Hard Estate. (Courtesy Elizabeth and Robert Martino.)

Four

MARY LOUISE BOOTH, AUTHOR

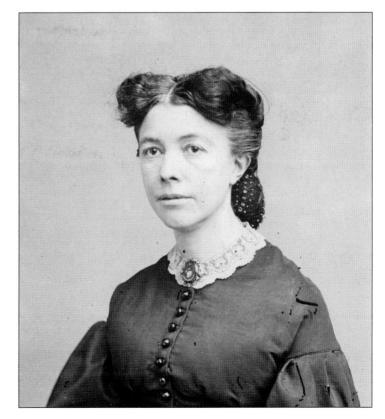

Mary Louise Booth, author, editor, translator, women's rights advocate, and abolitionist, was an esteemed figure in the world of publishing in America and Europe in the 19th century. She was born in 1831 in a small, wood-shingled house on Main Street in rural Yaphank and was a child prodigy, reading Plutarch and Racine by age seven. (Courtesy New York Historical Society.)

Quod ero spero, which appears on the Booth family crest, has been translated as "Hope, Perseverance, Success," or "What I hope to accomplish I shall accomplish." It has been passed down through the generations from 17th-century Cheshire, England. Mary Louise Booth was very proud of her family motto and lived by it, quoting it and using it on her personal stationery. (Courtesy Booth Family Genealogy.)

In 1829, William Chatfield Booth and his wife, Nancy Monsell, moved to Yaphank from Southold and built this wood-shingled Cape house, where they had four children. William Booth was the schoolmaster and also worked at the mills as a dyer. They lived here until 1845, when the family moved to Brooklyn, where William Booth was offered the position of headmaster at PS1 in Williamsburg and Mary Louise taught Latin. (Courtesy Suffolk County Historic Services.)

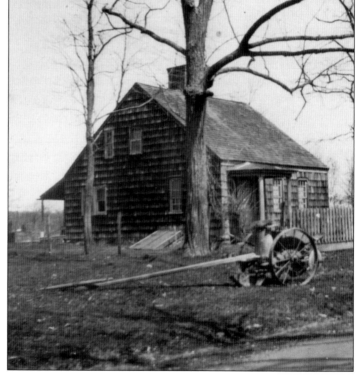

Gifted in translating from French, Mary L. Booth was in great demand and worked for several New York publishers. During this period, she translated 46 books and started writing her seminal work, the *History of the City of New York*. It was published in 1859 and was the first history of its kind. The book went into many editions, some with custom portfolios of etchings of New York City. (Courtesy W.R.C. Clark & Meeker.)

HISTORY

OF THE

CITY OF NEW YORK,

FROM ITS EARLIEST SETTLEMENT

TO THE PRESENT TIME.

BY

MARY L. BOOTH.

Woman's Rights Convention.

SARATOGA, Wednesday, Aug. 15.

The Women's Rights Convention assembled here to-day. The following officers were elected: President—MARTHA C. WRIGHT, of Auburn. Vice Presidents—Rev. Samuel J. May of Syracuse, Lydia Mott of Albany, Ernestine L. Rose of New-York, Antoinette L. Brown of New-York, Susan B. Anthony of Rochester, Augusta A. Wiggins of Saratoga Springs. Secretaries—Emily Jaques of Nassau, Aaron M. Powell of Ghent, Mary L. Booth of Williamsburg. Finance Committee—Susan B. Anthony, Mariette Richmond, Mary S. Anthony, Phebe Jones. Business Committee—Antoinette L. Brown, Ernestine L. Rose, T. H. Higginson, C. F. Henry of Boston, Phebe Merrill of Michigan, Hon. Wm. Jay of Saratoga Springs.

On moving to Brooklyn, Mary Louise Booth worked as a reporter for the *New York Times* writing women's pieces. She was also listed as secretary of the first Women's Rights Convention in Saratoga in a news piece the *Times* published in August 1855. Fellow officers included Susan B. Anthony, Lydia Mott, and T.H. Higginson (Emily Dickinson's mentor). (Courtesy the *New York Times*.)

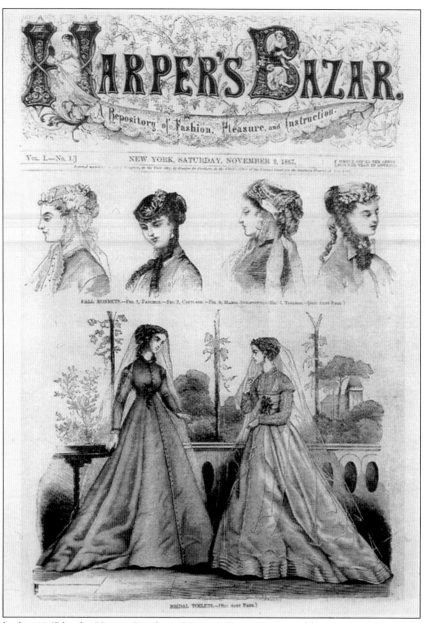

Established in 1867 by the Harper Brothers, *Harper's Bazar* was a weekly magazine for stylish women that was created by founding editor Mary L. Booth, where she reigned for 22 years. Featuring articles on fashion, home, entertaining, and current events, *Harper's Bazar* followed a template created by Booth that is still used by many women's publications today. She went on to touch the lives of thousands of women and influence their homes and lifestyles through the magazine's pages. She hired writers, such as Louisa May Alcott and Wilkie Collins, and artists like Winslow Homer for his illustrations. Traveling to Paris, London, and Venice, she brought back with her the latest fashions and insights into the culture of the time to share with her readers. She was also known for her world famous literary salons, which she held at her residence on Fifty-ninth Street and Park Avenue. She continued her esteemed editorial career until her death in 1889. (Courtesy Harper and Row.)

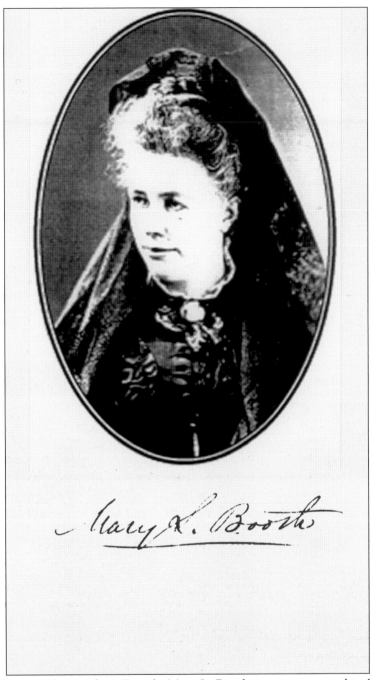

Known for her translations from French, Mary L. Booth was instrumental in bringing the news from France of their independence movement as well as their support of the Union and emancipation causes in the US Civil War. It is said that she stayed up several days and nights translating *Uprising of a Great People* for Abraham Lincoln, who was influenced by this treatise in writing his Emancipation Proclamation. She was thanked for her efforts in a letter written by William Seward, secretary of state, and signed by Abraham Lincoln. (Courtesy New York Historical Society.)

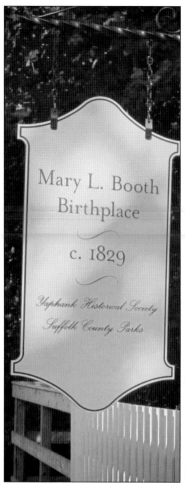

In August 2011, the Yaphank Historical Society opened the Mary Louise Booth Birthplace Museum in honor of her accomplishments. The history of her early life in Yaphank and her publishing career are on exhibit. Although she left when she was 14, she always returned to Yaphank to visit the village she loved, which was where she started her amazing life. She died in 1889 at the age of 58. (Courtesy Yaphank Historical Society.)

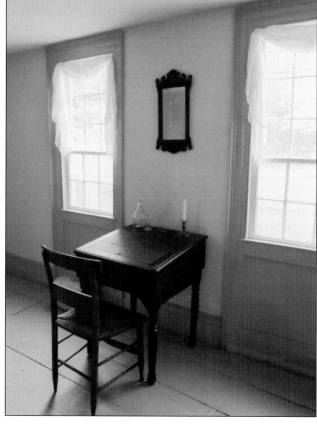

The Mary L. Booth House has been restored and interpreted to the year 1845, and period lilacs and apple trees are planted on the grounds. The chair she grew up with has been donated, and the local 19th-century schoolteacher's desk is in the parlor. (Courtesy Yaphank Historical Society.)

Five

A Sense of Community

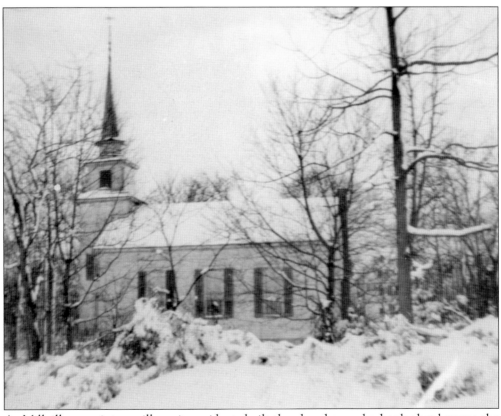

As Millville grew into a village, its residents built the churches and schools that became the heart of the community. Social life centered on activities promoted by the Presbyterian and the Episcopal churches. Concerned for the educational growth of its children, the town of Brookhaven established a school in Millville in 1815, and churches followed. (Courtesy Kay Walters.)

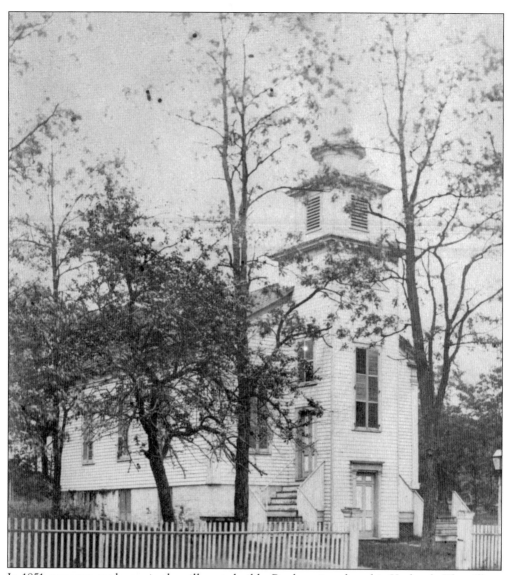

In 1851, a movement began in the village to build a Presbyterian chapel in Yaphank. The village had a new prosperity and did not want to travel to church in Middle Island. Van Renssaeler Swezey and Nathaniel Tuthill were presiding officers of the movement, and lists were circulated to collect monies for the endeavor. The list circulated by the well-to-do collected $729, while the not-so-well-to-do collected $375. Sums collected were intended to "purchase a site for the erection of a house for the public worship of God to be constructed in the Presbyterian form, in some suitable place to be selected between Yaphank mills on the lower lake and Swezey's mill on the upper lake." The congregation contracted Charles Woodhull from Sayville to build a meetinghouse for $1,060. Other expenses included $18 to Lester Homan for carting materials, $15 for digging the basement, $35 for painting the inside and out, $18 for stoves, and $1.75 for recording the deed, shutter fasteners, and a key. (Courtesy Longwood Public Library.)

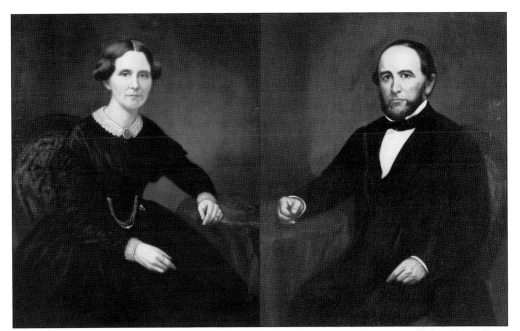

Samuel Fayette Norton and his wife, Eliza Swezey Norton, were prominent citizens in the village. She was the daughter of mill owner Christopher Swezey. He was a well-to-do farmer and builder and constructed their home at Swezey's Corner. Their portraits were restored by the Yaphank Historical Society after they were received as a gift from Nan Tomlinson, a descendant of the Nortons. (Courtesy Yaphank Historical Society.)

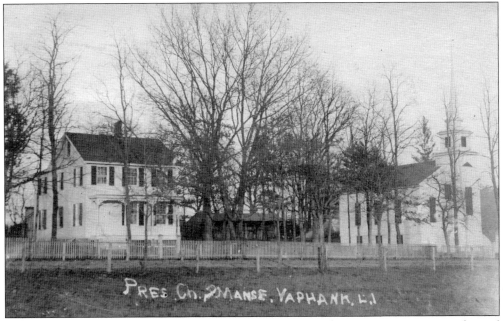

As the chapel continued to prosper, S.F. Norton and his wife, Eliza Swezey Norton, were devoted to the congregation. Both were very active members of the church, and Norton was a church elder. He added a steeple to the meetinghouse and built the parsonage next door to the church in 1871. For the first time, a church bell was heard in the village. (Courtesy Longwood Public Library.)

The Presbyterian manse, built in 1871 by S.F. Norton, was known as Oak Villa Parsonage. From 1888 to 1921, the Reverend James Denton lived there with his wife and daughters Anna and Lizzie. Reverend Denton shepherded a lively congregation where spiritual and musical events drew the entire village together. (Courtesy Longwood Public Library.)

The Reverend James Denton's father, W.C. Denton of Jamaica, visited the parsonage, where he published the *Yaphank Courier*. It carried local news and events and sold for 1¢ at the post office or 20¢ a year. When Reverend Denton retired, his daughters, the Denton sisters, were given lifetime permission to spend summers at the parsonage. They were a familiar sight in Yaphank for many years. (Courtesy Gary Ralph.)

E. Wickham Mills, a staunch Presbyterian and an eligible bachelor, ran the general store and lived on Main Street. He was described by L. Beecher Homan as being "cheerful with agreeable manners," which won him friends among the men. The Napoleonic twists of his mustache charmed the ladies, and for years he sang in the choir. (Courtesy L. Beecher Homan.)

EDWARD WICKHAM MILLS.

MOLLENHAUER
MUSIC!

Prof. LOUIS MOLLENHAUER, of Mollenhauer's Conservatories of Music, of Brooklyn, assisted by eminent N. Y. talent, will give a

GRAND MUSICAL CONCERT

in the

PRESBYTERIAN Church, YAPHANK, L. I.

Monday Evening, August 17, 1903,

At 7.45 P. M.

ADMISSION, THIRTY-FIVE CENTS.

Entire proceeds for the benefit of the church.

This will be a rare Musical Entertainment, and it is hoped a large audience will greet Mr. Mollenhauer on this occasion.

The Yaphank Presbyterian Church was the center of social life on Main Street. Frequent events were held there and attended by everyone in the village, including people of all faiths. Donations collected went to mission homes and abroad. From early on, church members supported the temperance movement, and meetings were regularly held in the church basement. (Courtesy Yaphank Historical Society.)

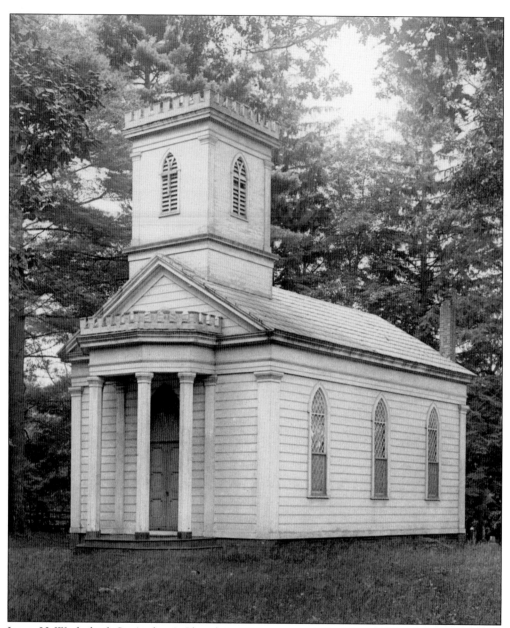

James H. Weeks built St. Andrew's Church in 1853 to memorialize his granddaughter Susan Maria Weeks, his wife's namesake, who was buried on the feast of St Andrew. The Weeks family also established the cemetery in the churchyard. Their granddaughter was the first member of the Weeks family to be buried there, a centuries-long tradition. In designing the church, the Weeks family was inspired by Old Grace Church in Massapequa. They not only desired to import a distinctive architectural style, but they had the means to do so as Weeks acquired wealth from his successful businesses. The architecture represents the vernacular Gothic embellishments in a building with basic, Greek Revival lines. In 1872, Charles Jeffrey Smith of the Manor of St. George liquidated the $500 debt on the building and made the contribution in memory of his wife, Letitia Smith. In 1873, the church and adjoining land was conveyed to the diocese of Long Island. It is listed in the National Register of Historic Places. (Courtesy Carol and David Dew.)

St. Andrew's Church is decorated with pine boughs and holly for the Christmas service, a ritual that the Weeks children performed for many years in memory of their sister, "Little Susy." The Weeks family also provided a minister for Sunday services and maintained the building for the community. (Courtesy St. Andrew's Church.)

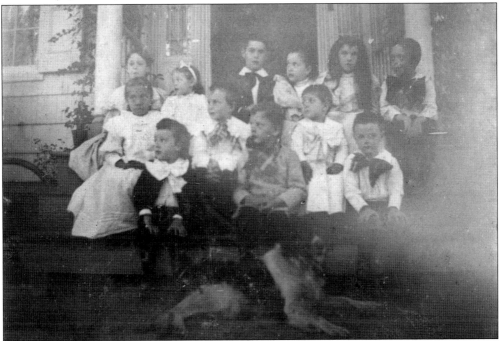

Yaphank's most prominent families attended St. Andrew's. In 1895, the Sunday school met at The Lilacs. Listed from left to right, they are (first row) Harry Davis, Charlie Gerard, and Felix Blonsky; (second row) Ethel Marvin, Charlie Swezey, and Dudley Lawless; (third row) Abbie Blonsky, Leonie Phillips, Clarence Warren, Natalie Lawless, Florence Davis, and Kellog Dominy. (Courtesy Robert and Elizabeth Martino.)

On November 30, 1852, Susan Maria Weeks pressed this little branch of "the flower of innocence," which was taken from the grave of "Little Susy," who had died two years before. (Courtesy Yaphank Historical Society.)

The youngest child of William Weeks, Laura Antoinette Weeks, married Daniel Hesselberg at St. Andrew's Church. All the Weeks children were married there. At the conclusion of the ceremony, the bridal party, accompanied by many relatives and friends, celebrated at the bride's father's house, The Octagon House, where an elegant reception was held in their honor. (Courtesy St. Andrew's Church.)

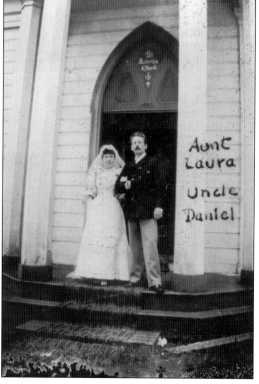

Clara Weeks devoted herself to the service of her church, which was dedicated to the memory of her sister. During the summers, she requested that students be sent to preach at St Andrew's. Many of these young students went on to become bishops and canons and never forgot her. One year, she was the guest of honor at a theological convention in Albany, New York, and was the only woman present. (Courtesy St. Andrew's Church.)

On Easter 1903, St. Andrew's Episcopal Church celebrated the 50th anniversary of the Sunday school. In the background of this photograph, The Lilacs, the home of Susan Maria and James Weeks, can be seen. Sunday school was started and taught by Susan Maria and held every Sunday in the parlor of The Lilacs. (Courtesy Richard Chapin.)

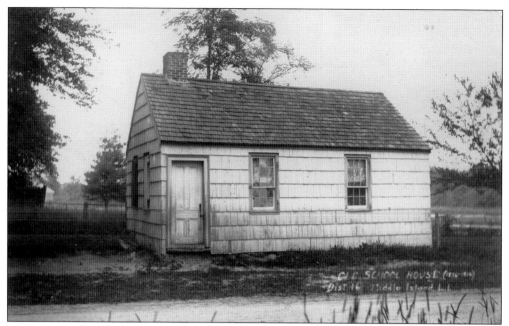

The Town of Brookhaven met in November 1813 to create 13 school districts. Six 20-foot by 24-foot one-room schoolhouses were built with a consistent look. Millville's school stood just north of Swezey's Corner. By 1850, many villagers wanted to abandon the old, dilapidated school, feeling its location was too far on the outskirts of the village. William Chatfield Booth and his daughter Mary Louise Booth taught here. (Courtesy Town of Brookhaven.)

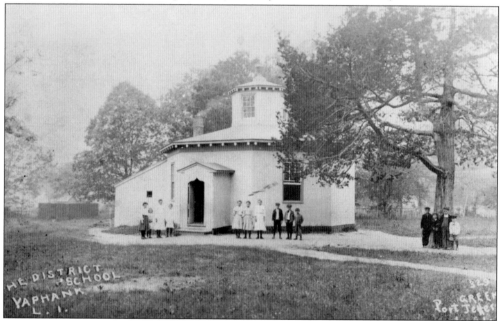

Its students referred to Yaphank's village school as the "Butter Churn" due to its look. William J. Weeks, school superintendent, designed the distinct, one-room, octagon schoolhouse with a cupola for ventilation. Land was purchased for the schoolhouse in the center of the village in 1854. (Courtesy Edythe Davis.)

Gus Neuss, a longtime resident of Yaphank, sketched this layout of The Octagon Schoolhouse, which he attended. The school was heated by a potbellied stove, and fuel for the stove was stored in the woodshed. Large windows and a cupola allowed sufficient sunlight except for the cloudiest of days. The American flag was prominent, and busts of America's forefathers stood on pedestals around the room. (Courtesy Longwood's Journey.)

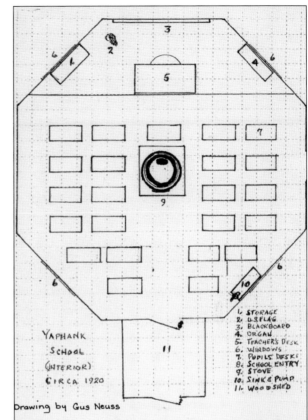

Ada Randall taught at Yaphank's octagon school in 1891. She had to provide instruction in reading, writing, arithmetic, and geography for grades one through eight. There were usually no more than a few children at each grade level. When one group was receiving instruction, the rest of the class was expected to study or listen in on a higher level's lessons. Discipline was stern and swift. (Courtesy Longwood Public Library.)

YAPHANK
SCHOOL
(INTERIOR)
CIRCA 1920

Drawing by Gus Neuss

1. STORAGE
2. U.S FLAG
3. BLACKBOARD
4. ORGAN
5. TEACHER'S DESK
6. WINDOWS
7. PUPILS' DESKS
8. SCHOOL ENTRY
9. STOVE
10. SINK & PUMP
11. WOOD SHED

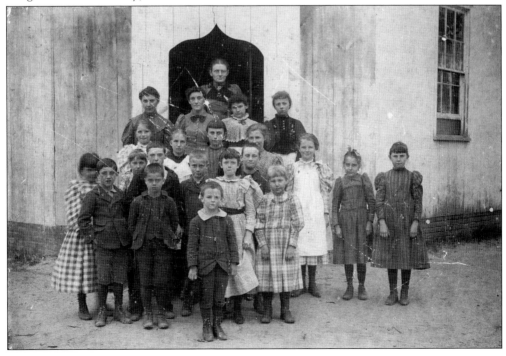

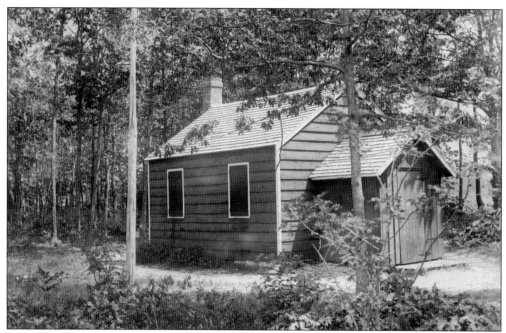

In the 1870s, the West Yaphank School was attended by many West Yaphank students, but never at the same time, as the older children had to take time off when needed for harvesting. The school burned down in 1906 and was replaced by a new school built on the same site. (Courtesy David and Carol Dew.)

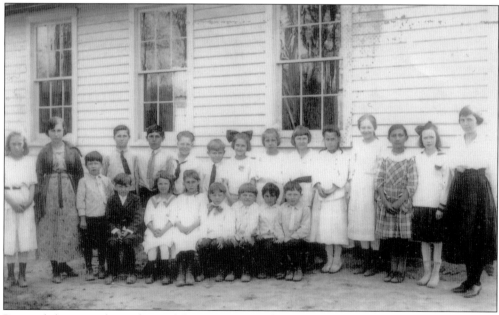

Pictured above are the students of the new West Yaphank School. The school just had one room heated by a wood stove at one end. The students stood behind their slanted-topped desks, which ran around the perimeter of the room. Wood benches were placed in the center of the room. Generations of Yaphank's children went to school here until the 1950s. (Courtesy Longwood Public Library.)

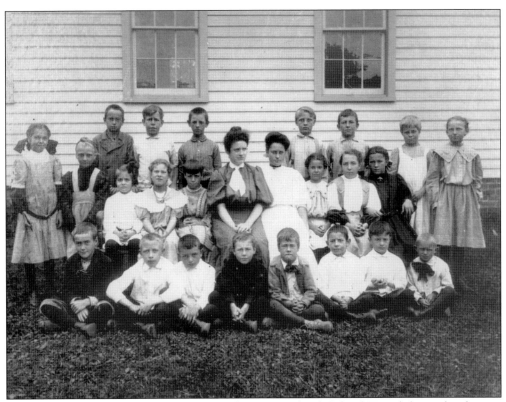

This undated class photograph was taken at the West Yaphank School. From left to right, they are (first row, on ground) unidentified, Henry Foray, Charles Smotteny, unidentified, George Read, two unidentified, and George Foray; (second row, seated) Lindell Weidner, Helen Read, unidentified, Cecil Bliss (teacher), Eva Champain, Helen DeMarre, unidentified, and Marcel DeMarre; (third row, standing) unidentified, Emma Mikosky, Arthur Hawkins, Richard Hawkins, Will Mikosky, two unidentified, Carrie Reese, and Bertha Mysitveech. (Courtesy Shirley Olsen.)

This program was presented to the graduating students of Miss Steeleman's 1916 class at the West Yaphank School. She presented it as a souvenir lest they forget the pleasant memories of the happy days spent together in the classroom. (Courtesy Shirley Olsen.)

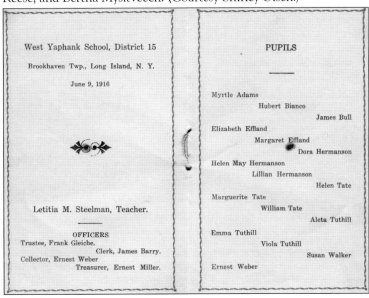

West Yaphank School, District 15

Brookhaven Twp., Long Island, N. Y.

June 9, 1916

Letitia M. Steelman, Teacher.

OFFICERS
Trustee, Frank Gleiche.
Clerk, James Barry.
Collector, Ernest Weber
Treasurer, Ernest Miller.

PUPILS

Myrtle Adams
Hubert Bianco
James Bull
Elizabeth Effland
Margaret Effland
Dora Hermanson
Helen May Hermanson
Lillian Hermanson
Helen Tate
Marguerite Tate
William Tate
Aleta Tuthill
Emma Tuthill
Viola Tuthill
Susan Walker
Ernest Weber

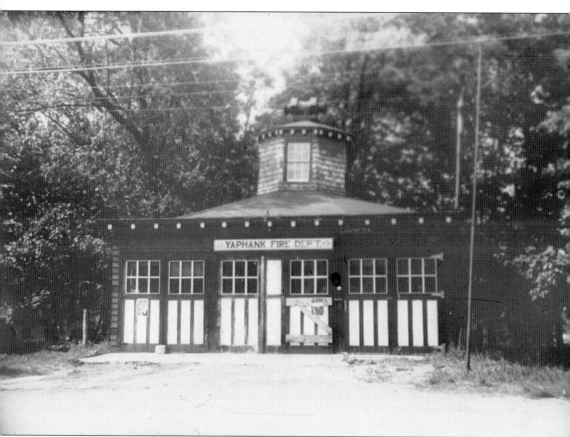

In 1926, a new school was built in front of the old octagon school on Main Street. In that same year, the Yaphank Fire Department was formed. In 1927, the old octagon school was lifted and moved east to the old Baptist Missionary property on Main Street. It was not unusual for buildings to be moved and repurposed at this time. It became the home of the newly formed fire department. It was painted green with red trim. New double doors were installed, and the fire alarm was hung on top of the cupola and shook the building when it rang. It was not until 1947 that the site was purchased from the Baptists. In 1951, the property was sold and the building demolished. Mary Walters donated property for a new fire department to be built. (Courtesy David Overton Collection.)

Six

LIFE ON MAIN STREET

At the intersection of Yaphank and Main Streets at the turn of the 20th century, shops and services were plentiful. From Howell's General Store, to the blacksmith shop, to James E. Weeks Painting Shop, it was the place to go to take care of business on the way to Gerard's Mills. (Courtesy Longwood Public Library.)

Thomas Homan tilled a large farm on the edge of the village. Most early farmers grew potatoes, hay, and corn. Thomas was the youngest of three sons of Mordecai Homan. Well liked by his neighbors, they referred to him as "Uncle Tommy." He is buried in the Presbyterian churchyard. (Courtesy Gary Ralph.)

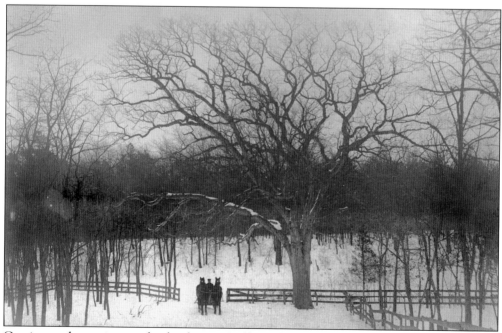

Coming up the carriage road to his farm on Mill Road, Thomas Homan drives a two-horse-team sleigh with a great oak seen in the background. Homan passed the family farm to his son Edward. Typical of farms on the edge of the village, it was enclosed with paddock fencing. (Courtesy Gary Ralph.)

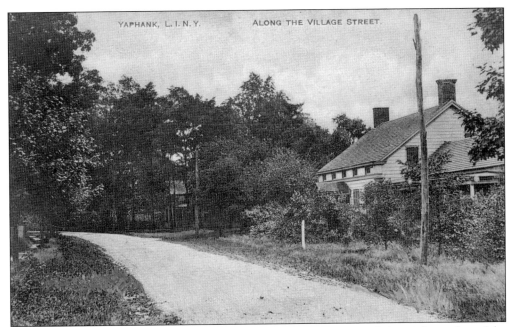

S.F. Homan was one of Yaphank's leading citizens; his house is pictured above. A member of the Presbyterian Church, which was the center of cultural life in the village, he sang in the chorus as a tenor and sang solos as well. He was the founder of Yaphank Grange No. 1342 in 1913, and through his efforts, electric lights were installed in Yaphank in 1918. (Courtesy Longwood Public Library.)

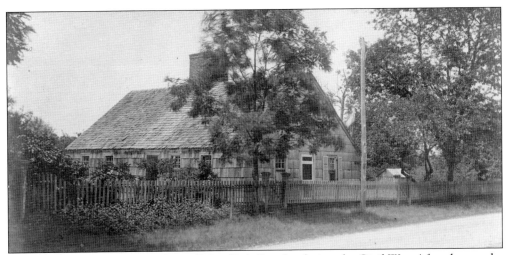

Richard Homan fought with the 2nd New York Cavalry during the Civil War. After the war, he and his wife, Georgianna, lived here with their son Benjamin. Richard Homan became a seaman and captained a number of ships. When he became too ill to leave his house, he enjoyed having religious meetings at home. This house, one of Yaphank's oldest, still stands on Main Street. (Courtesy Longwood Public Library.)

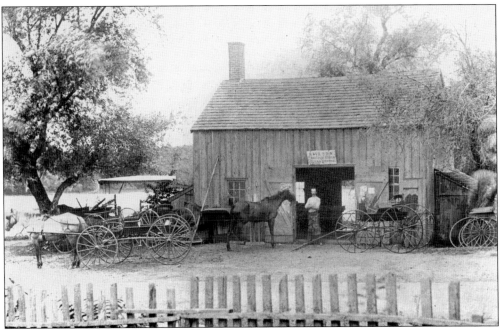

The first blacksmith shop of A. Iveson stood on the east side of the upper lake near Swezey's Sawmill. Albert E. Bayles noted on September 15, 1899, in his diary, "On Sunday morning about 2 o'clock, the blacksmith of A. Iveson and the wheelwright shop of Alfred Ackerley burned down." (Courtesy Thomas R. Bayles Collection.)

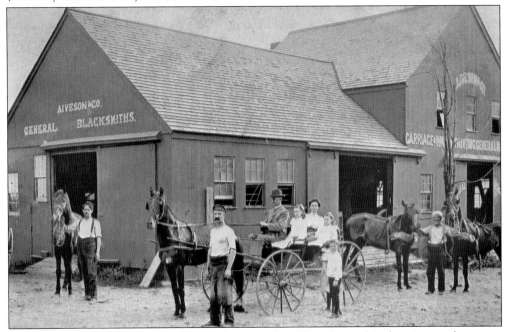

Alexander Iveson built a bigger and better shop after his old one burned. Its location on the corner of Main Street and Mill Road was convenient to have a horse shod or a broken farm implement repaired while one shopped at nearby stores. This second shop burned in 1915. (Courtesy David and Carol Dew.)

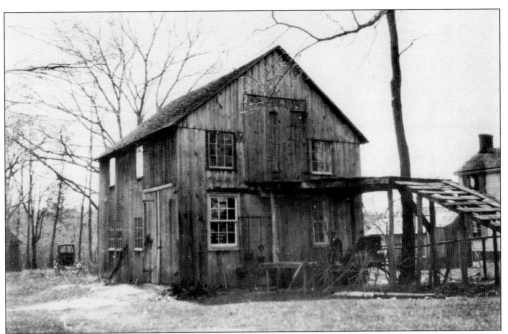

Charles H. Marvin was Yaphank's premier carriage maker. His stages and wagonettes were built to order for customers as far away as Setauket. He also did painting and "general jobbing." J. Wendling later owned the building. Today, it is a private residence known as the Old Carriage House. (Courtesy Longwood Public Library.)

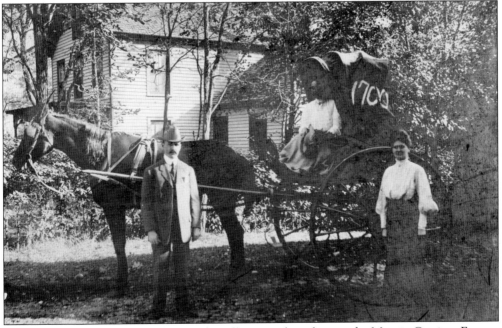

This one-horse shay was rented out to the villagers and was kept at the Marvin Carriage Factory on Main Street. Marvin enjoyed collecting old relics and used to hunt for them on Fire Island with William Weeks. There was also an operating wheelwright shop and a blacksmith shop in his factory that dated back to 1780. (Courtesy Yaphank Historical Society.)

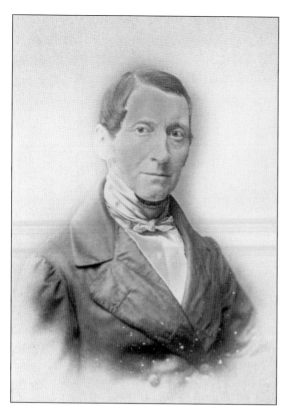

Augustus Floyd, grandson of William Floyd, a signer of the Declaration of Independence, was born at the Floyd Estate in Mastic. He graduated from Yale College in 1813 and practiced law in New York City. He never married and left his fortune to his nieces and nephews. (Courtesy William Floyd Estate, FINS No. 17349.)

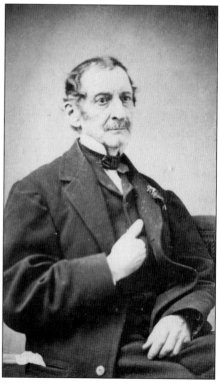

In 1849, Augustus Floyd suffered chronic deafness and had to give up a successful law career. He retired to Yaphank, as he had family connections there, became a gentleman farmer, and owned a small farm run for him by W.H. Robbins. He was known for his love of solitude and kept to himself, spending his days with his books and correspondence. (Courtesy William Floyd Estate, FINS No. 17404.)

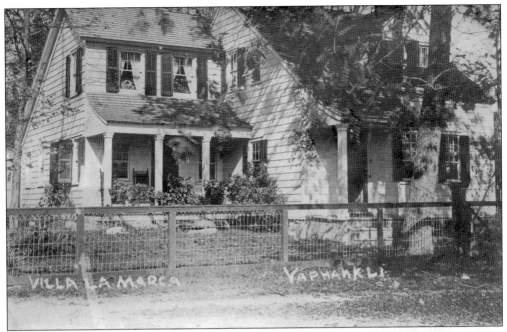

In later years, Augustus Floyd's wood-shingled house on Main Street was sold to Signor De La Marca, who gave singing lessons there as well as in New York City on West Thirty-first Street. He taught the "old Italian" school of singing, and his home became known as Villa La Marca. (Courtesy Longwood Public Library.)

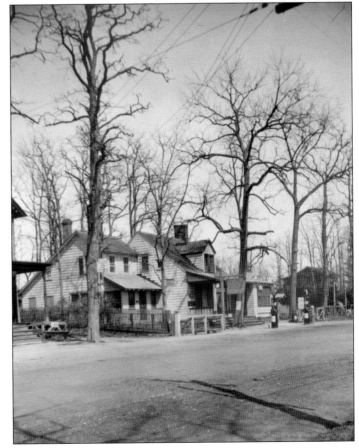

During World War I, the old Augustus Floyd house was transformed into a tearoom called the Villa Butterfly, as it was advertised in the *Patchogue Advance*. After the war, it became a store and gas station. It was later moved farther back on the property to become a private residence again in the 1930s. (Courtesy Longwood Public Library.)

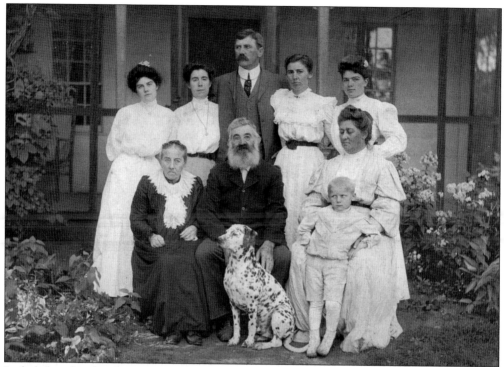

Included in this family portrait taken at a summer gathering are, from left to right, (first row) Augusta Hagelstein Neuss, Henry Joseph Neuss, Lillian Neuss Cassella, and Henry Neuss Cassella; (second row) Kate Hagelstein, unidentified, Dr. William Neuss, Augusta Neuss, and unidentified. In later years, Doctor Neuss ran his medical office out of his home on the north side of Main Street. (Courtesy Olive Archer.)

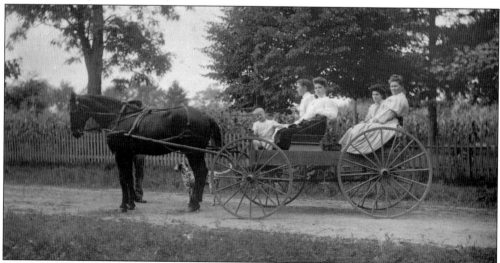

A last-minute adjustment is made to the harness of the horse in preparation for an afternoon wagon ride. Since Henry Neuss Cassella is the smallest, he rides in front while Augusta Neuss holds the reins. An unidentified woman sits next to her. In the back seat are, from left to right, Kate Hagelstein and Lillian Cassella. Visiting friends was an enjoyable summer afternoon ritual. (Courtesy Olive Archer.)

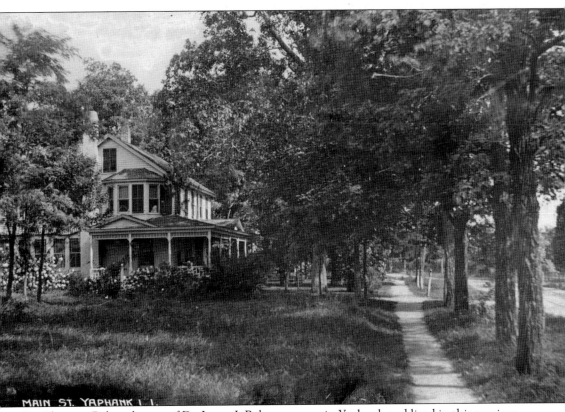

MAIN ST. YAPHANK L. I.

Dr. Clarence Baker, the son of Dr. James I. Baker, grew up in Yaphank and lived in this spacious house across from The Octagon Schoolhouse down the road from his parents. Graced with wide Victorian porches across the front and perennial borders, it was the first house to have running water, electric lights, and steam heat. He went to Cornell and was known for coming home from college with a sporty roadster, and his was one of the first families on Main Street to have an automobile. He took over his father's medical practice and made the transition to making house calls with his automobile instead of horse and carriage. Later, he was attending physician at the almshouse and Children's Home. He was also on the board of the Union Savings Bank in Patchogue. He married Mary E. Gerard of Brookhaven in 1898. (Courtesy Longwood Public Library.)

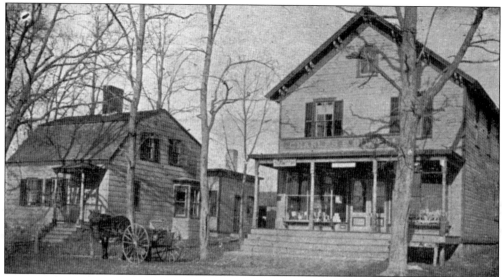

In 1897, Charles E. Howell took over the dry goods and grocery store formerly owned by Edwin Hawkins. Pictured here is Old Kate, who pulled the store's wagon. The Howells also had boarding and livery stables on the site and ran stages for picnic parties and fireman tournaments. The County Clerk's Office was attached to the building. (Courtesy Edythe Davis.)

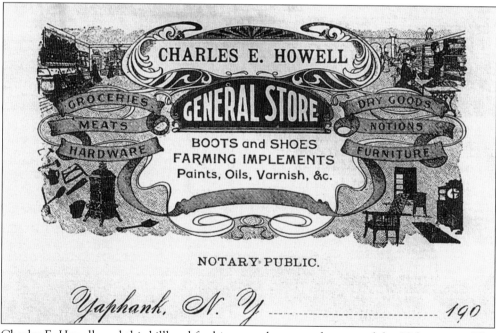

Charles E. Howell used this billhead for his general store at the turn of the 20th century. The advertising indicates that Howell's store provided one-stop shopping, from groceries to farm implements to dry goods. The safe used at the store with "Charles E. Howell" stenciled in gold leaf has survived and is on display at the Yaphank Garage on Main Street. (Courtesy Yaphank Historical Society.)

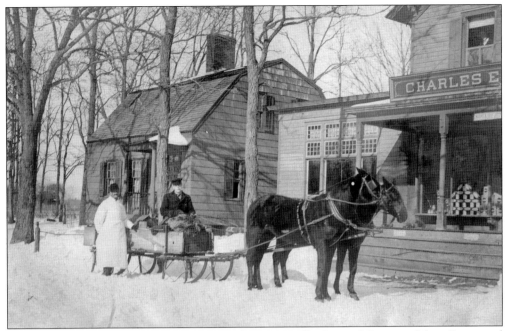

Serving the village from 1897 to 1921, Charles E. Howell's General Store on Main Street and Yaphank Avenue could be depended upon to stock needed supplies during the fiercest of winters. When a wagon was not an option, villagers hooked up a sleigh for provisions. In 1940, the building was moved east on Main Street to become a private residence. (Courtesy Gary Ralph.)

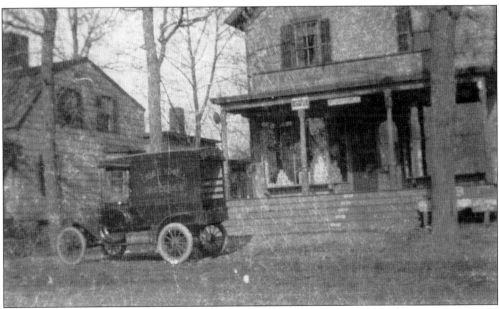

At Howell's store, the automobile was beginning to be a familiar site. Charles E. Howell would deliver groceries and other household necessities, such as men's scarlet all-wool undershirts and drawers. Times had changed, but the needs of his customers had not. The Howells sold the store to Peter D. Tiedemann in 1921. (Courtesy Yaphank Historical Society.)

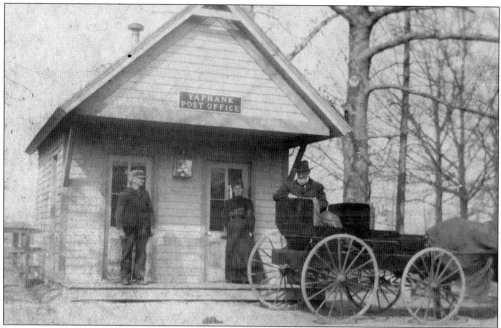

Over the years, the Yaphank Post Office has moved up and down Main Street. Here, Mabel Carman stops to collect her mail. Yaphank had applied for a post office in 1844 when it was known as Millville. There were already 11 Millvilles in New York State, so they were advised to come up with another name. As mentioned before, "Yaphank" is an Indian name meaning "bank of the river." (Courtesy St. Andrew's Church.)

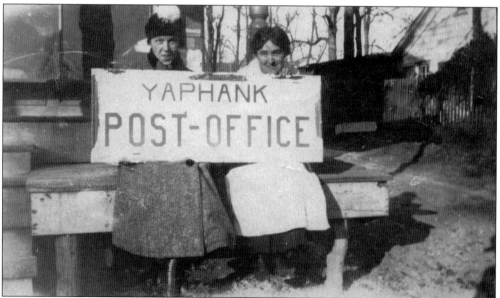

Nellie and Anna Gordon posed for this postcard photograph in front of the Charles E. Howell store. Anna later married Albert Davis, a Yaphank builder, and lived next door to the store for the rest of her life. Nellie married George Prosser and lived at the Prosser Pines homestead, now a Suffolk County park in Middle Island. The two sisters remained close throughout their lives. (Courtesy Edythe Davis.)

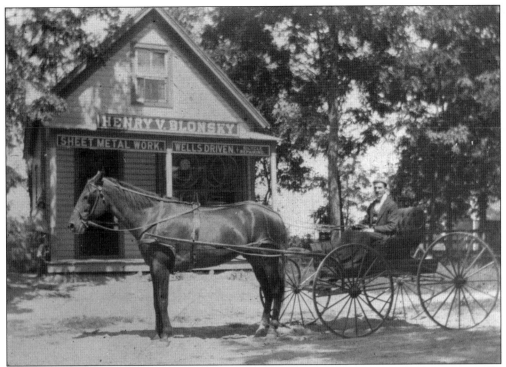

In the early 1900s, the post office was run out of Blonsky's Bicycle Shop, which was centrally located on Main Street. Henry V. Blonsky's salary in 1906 was $528, and postage was 2¢ for a letter. He was civic minded and popular in the village and was also active in St. Andrew's Episcopal Church. (Courtesy Yaphank Historical Society.)

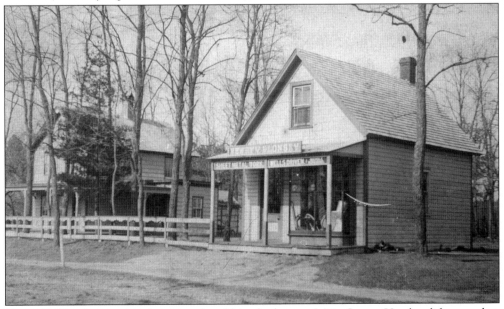

Henry V. Blonsky ran this sheet metal and bicycle shop on Main Street. He also did steam, hot water, and hot-air heating; drove wells; and did hydraulic pump work. When the old well at the Four Corners in Coram gave out, it was Blonsky who drove the new well. (Courtesy Edythe Davis.)

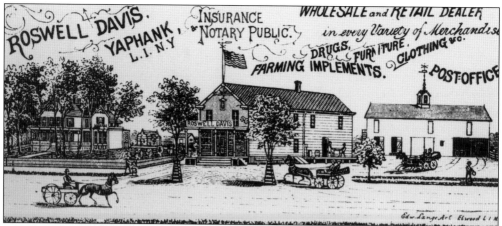

In 1881, Roswell Davis opened a large store complex on Main Street in the center of the village. Ten years later, on July 2, 1891, the *Yaphank Courier* quoted him as saying, "I don't believe it does any good to advertise how cheap one is selling goods. No matter how brilliant one waxeth, it is the price that does the business." (Courtesy Yaphank Historical Society.)

Roswell Davis operated a general store that was considered one of the best in Suffolk County. He was also active in local politics. He was postmaster of the village for many years, and in 1890, he was the first Republican to be elected clerk of the Town of Brookhaven. In 1892, he became a manager of the Sun Insurance Agency and opened agencies throughout the county. (Courtesy *Long Island Boroughs and Counties*.)

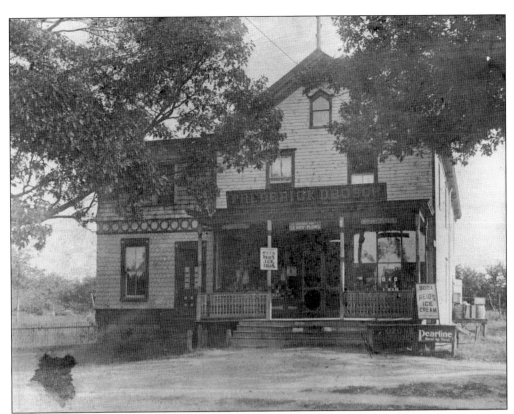

The Frederick D. Bosch General Store stood on Main Street from 1904 to 1908. Bosch had been born and raised in Brooklyn and was a printer by trade. When he married Ella Green in 1903, they decided to move to Yaphank and open the store. Bosch's was the first store in the village to carry Reid's Ice Cream. (Courtesy James and Jean Vavrina.)

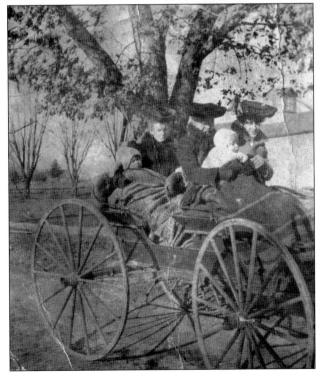

The Bosches family is bundled up for drive down Main Street in early spring. Margaret Bosch is holding Edmund and Ella Green Bosch in the front of the wagon. The women and child in the back seat are relatives who were out for a visit in the country from Brooklyn. (Courtesy James and Jean Vavrina.)

Elsie Webber grew up in Yaphank, where she and her brothers and sister Ophelia attended the West Yaphank School in the 1870s. Elsie married Edward Dew and moved to his farm at Bellport Station on Sills Road. Elsie and Edward had two children, Edward Samuel Dew and Mary Dew. Elsie's sister Ophelia married A. Iveson, who ran the blacksmith shop in Yaphank. (Courtesy David and Carol Dew.)

Edward Dew emigrated from England to the United States, arriving in Boston and making his way to Yaphank. He married his first wife, Jane Tuck, at St. Andrew's Church in 1875. After her death, he married Elsie Webber. Both Edward and Jane are buried where they were married. (Courtesy David and Carol Dew.)

Charles E. Walters was born in Great Neck and operated a farm in Floral Park before moving to Yaphank in 1911. He bought the 250-acre farm that had formerly been owned by the Tuthill family. He housed his workers at the farmhouse and lived farther east on Main Street. A gentleman farmer, he also owned land at Artist Lake. (Courtesy Kay Walters.)

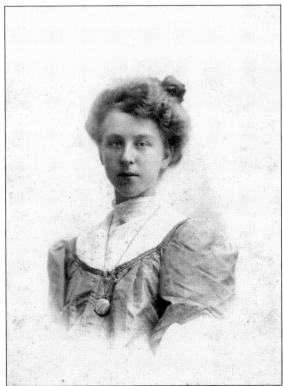

Mary Augusta Walters was the devoted wife of Charles E. Walters. After his death, she donated land for a new elementary school that was built in 1953 and named Charles E. Walters. It was a fitting tribute to her husband, who served as chairman of the Yaphank Board of Education. (Courtesy Kay Walters.)

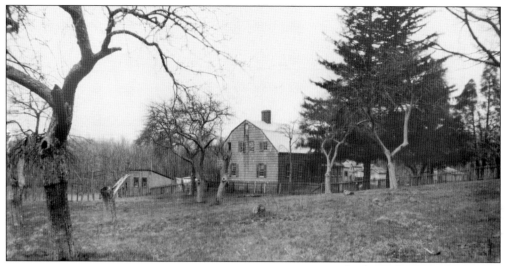

Yours, truly,
L. B. Homan

In the early 1800s, S.L. Homan lived at this farm, which stood at Middle Island Yaphank Road. He was a well-respected farmer and member of the Presbyterian Church. He had three sons, Samuel F. Homan, Frank M. Homan, and L. Beecher Homan. His son L.B. Homan was the author of *Yaphank As It Is and Was and Will Be*. In 1885, postmaster general Vilas appointed S.L. Homan as postmaster of Yaphank. (Courtesy Longwood Public Library.)

In 1875, L. Beecher Homan published *Yaphank As It Is and Was and Will Be*. The book profiled Yaphank's prominent citizens and documented the beginnings of its churches and schools. He later moved from Yaphank to Port Jefferson to become editor and then owner of the *Port Jefferson Times*. Fortunately, he wrote this book, ensuring that Yaphank's early history will not be forgotten. (Courtesy L. Beecher Homan.)

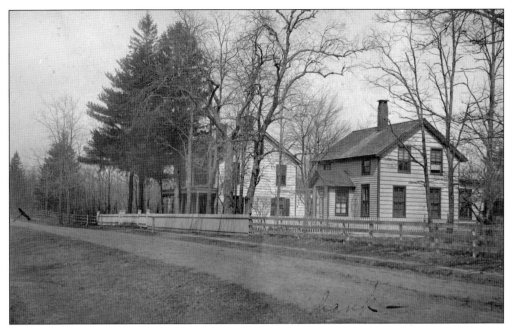

A.P. Homan lived in the house in the foreground, not far from Swezey's Corner. Next door was the home of Alfred Ackerly. Alfred worked in Brooklyn during the week, and his wife took in summer boarders. In 1890, the Ackerlys built a sidewalk and set their new "tie posts" so that when horses were fastened to them, they would not walk on the sidewalk. (Courtesy Gary Ralph.)

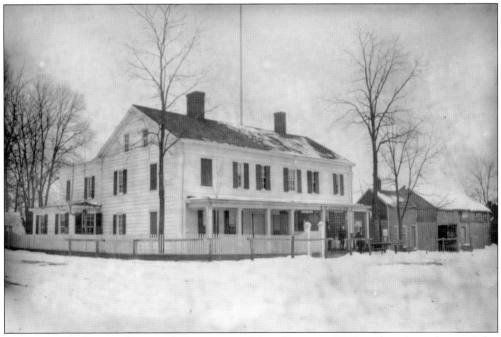

Capt. Wheelock Coombs owned this store on Main Street in 1877, and to the right was John Hammond's shoemaker shop. Both buildings burned in 1883. In 1884, Robert Finley Hawkins purchased the property, and he built a new store called Robert F. Hawkins and Son, which eventually sold to Charles E. Howell. (Courtesy Brooklyn Public Library-Brooklyn Collection.)

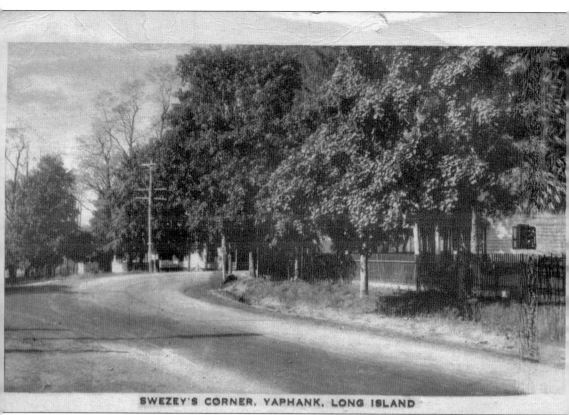

SWEZEY'S CORNER, YAPHANK, LONG ISLAND

Swezey's Corner was named for the Swezey family home, pictured at right. At this busy intersection, villagers and visitors came to the sawmill on the west side of the millpond or east to Main Street to shop, collect their mail, get the local news, and conduct their business. (Courtesy Longwood Public Library.)

100

Seven

LAKESIDE

A shaded path that followed along the "going over" on the upper millpond was sometimes referred to as "the lovers' path." Residents and visitors alike enjoyed quiet strolls beside the lake. Across the lake, a large barn and a small summer cottage can be seen. (Courtesy Longwood Public Library.)

E. Hammond's photo-finishing works was run from his home on East Main Street. Film was developed for 10¢ a roll, and Kodak cameras were leased by the hour. He advertised "summer views in any costume, comic or masquerade." Whenever Yaphank celebrated, Ed Hammond was there to record the event. (Courtesy St. Andrew's Church.)

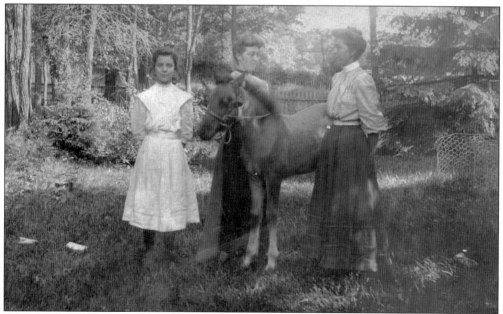

Everyone had postcard photographs taken by Edmund Hammond. There was no subject unworthy, as this photograph of the Gordon women with their three-month-old horse Peter illustrates. This card was sent to a friend who was sick at the hospital in Jamaica. For 1¢ postage, the family could keep in contact with each other. (Courtesy Edythe Davis.)

A Hammond postcard photograph featuring Peter, a three-month-old horse, was sent to friends and family in 1908. Horses were so important for farm work and transportation and were treasured by their owners. It was a time when blacksmiths and wagon makers were important village industries. (Courtesy Edythe Davis.)

A wide dirt avenue that passes assorted farm buildings, acres of rich farmland, and open fields surrounded by neat paddock fencing speaks to the rural character of Yaphank. It was a good place to farm and raise a family and was a nice place to call home. (Courtesy David Overton Collection.)

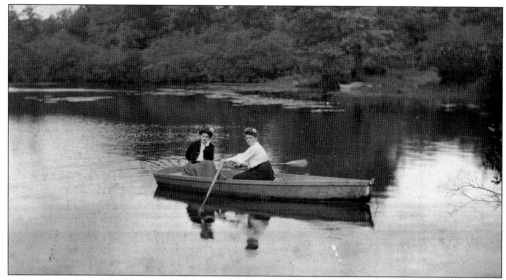

A friend rows Kate Hagelstein on the lower millpond, known as Lily Lake. This millpond was created when the Connecticut River was dammed to power the mills in 1762. Yaphank's lovely lakes have enriched the lives of those who have lived there for over 250 years. (Courtesy Olive Archer.)

Where people canoe today, Native Americans once hunted and fished. Old-timers tell of finding arrowheads along the banks of the Carmans River when they were young. Farther downriver in the area around Weeks Pond, archaeologists have found evidence of early Unkechaug campsites. (Courtesy Edythe Davis.)

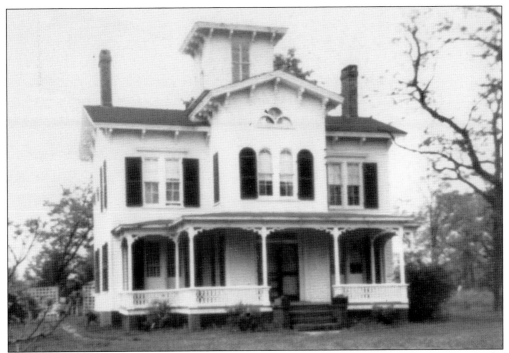

Robert Hewlett Hawkins was the son of mill owner Robert Hawkins. After having a career in the mercantile trade in New York City, he retired at 38 and returned to Yaphank, where he built this Victorian Italianate country home on the banks of lower Lily Lake. He lived here with his wife, Isabella, and three daughters for a few years before dying suddenly of a fever in 1855. (Courtesy Yaphank Historical Society.)

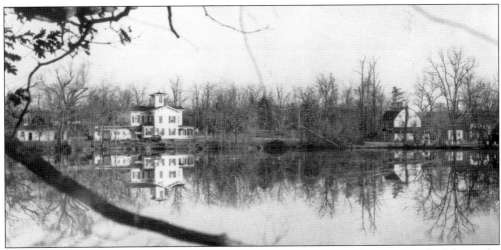

In the late 1800s, people called Yaphank's lower lake Lily Lake. Looking across the lake to the right is the Homan Gerard House and the old mill site. The large house on the left is the Robert Hewlett Hawkins House. Both houses are in the National Register of Historic Places. (Courtesy Yaphank Historical Society.)

Yaphank's lakes have always provided peace and solitude. This boathouse on the upper lake allowed its owner a quiet day's fishing from the shore or the dock or for a quiet row down the river. Today, one can still experience the peace and solitude of the river. (Courtesy Longwood Public Library.)

This postcard view of Yaphank's Main Street has a message written around its edges. This is because before 1907, only the address could appear on the reverse side of the photograph. In 1907, the backs of postcards were divided to allow for both a mailing address and a message. This postcard was sent in 1906. (Courtesy Longwood Public Library.)

The beautiful Carmans River rises as a tiny stream in Middle Island near Route 25. It flows southward towards Yaphank's Willow Lake, behind the south side of Main Street, and all the way to Yaphank's lower Lily Lake. It streams through Southaven Park and then empties into the Great South Bay. (Courtesy Edythe Davis.)

"Our twin lakes furnish an opportunity for boating, bathing and fishing and the most beautiful specimens of that peerless pond lily are gathered from the cool clear waters," claimed the *Long Island Advance* in August 1883. (Courtesy David Overton Collection.)

A shaded and well-worn path winds its way along East Main Street. The Lilacs, a boardinghouse run by Clara Weeks, can be seen in the distance. It was a short walk from Clara's to Yaphank's lower millpond, where rowboats could be rented. (Courtesy Gary Ralph.)

A summer boarder patiently waits in the hallway in one of Yaphank's many boardinghouses. In 1890, the local newspaper reported, "Boarders from the city are flocking to this romantic spot in record numbers." That August, a magical lantern exhibition was one of the entertainments offered at the Presbyterian Church. The admission was 10¢. (Courtesy Gary Ralph.)

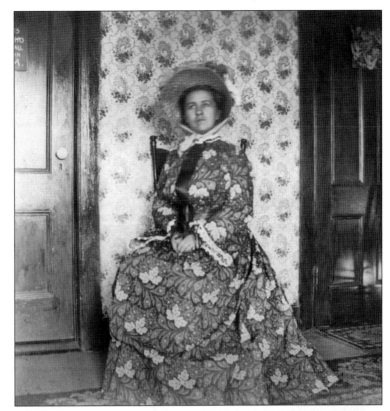

The message on the reverse side of this postcard describes the view from the window. "The path leads west where I go swimming, a short distance from this view. I can hear the water as I sit looking out at the boats." (Courtesy Longwood Public Library.)

Alice Outwater Fogarty owned a lovely home on Long Island Avenue. Her backyard sloped down to Lily Lake. Alice rented rowboats from her backyard to summer boarders. Some wanted to fish, while others just wanted to row around and enjoy the scenery. (Courtesy Edythe Davis.)

John and Marie Jones, pictured here on a boat on the Carmans River, had nine children and farmed 65 acres on the hillside at Sills and Mill Roads. Their son Henry James Jones was killed at the Argonne Forest, France, in 1918. The Henry James Jones VFW Post in Medford is named for him. The elder Jones served on the election board for 43 years. (Courtesy David and Carol Dew.)

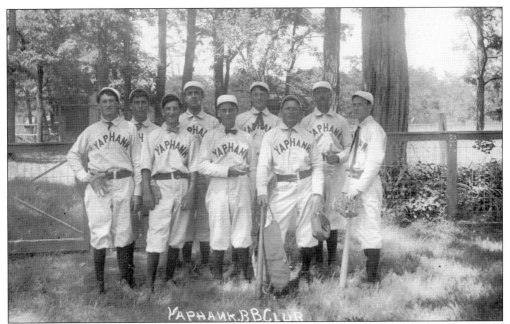

Yaphank loved baseball. They played against teams in Coram, Middle Island, and Bellport. Early on, they were known as the Athletics and played games at the Suffolk County Almshouse. In later years, they played ball at a field on Gerard Road. This was Yaphank's team around 1906. (Courtesy Edythe Davis.)

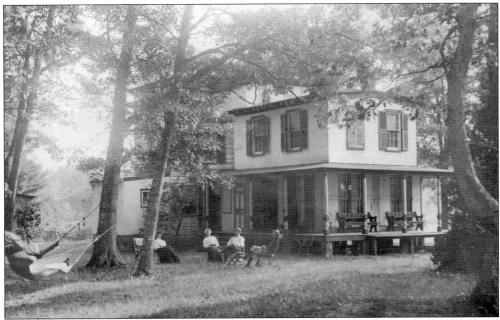

The Weeks Octagon House remained a family gathering place after the death of its patriarch, William Weeks. The Weeks children traveled to Yaphank by train with their families for weekend visits. Clara Weeks and her brother and sister-in-law, James and Antoinette, picked everyone up at Yaphank station. Croquet and cycling were favorite pastimes. (Courtesy St. Andrew's Church.)

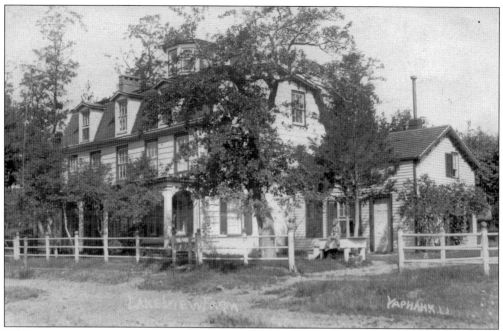

Lakeview Farm was the home of James Coombs. It was a beautiful lakeside property that stood on Mill Road west of the upper dam and adjacent to the millpond. In 1918, the Lakeview Farm had an abundant display of asters and other flowers appreciated and noted upon by all who passed the farm. (Courtesy Longwood Public Library.)

"Yaphank is a cozy village built upon a clearing in the woods with such a setting as an artist will travel far to find. Farming to a large extent, occupies the attention of the inhabitants." This description was found in the tourist brochure published by the Long Island Railroad called *Land of the Sunrise Trails*. (Courtesy Edythe Davis.)

In 1890, Elmer E. Homan was a breeder of rosecomb brown leghorns. He took great pride in his poultry, shipping them from Yaphank Station to points far and wide. Each year, he entered his leghorns to be judged at the Suffolk County Fair in Riverhead and always brought home prizes for their excellence. (Courtesy Longwood Public Library.)

Coming from Coram to Yaphank, one would travel on Mill Road. Along that winding dirt road, one would come upon the Twin Oaks at a bend. Just beyond that bend were the Lakeview Farm and Swezey Sawmill. Though the Twin Oaks and the sawmill are long gone and Lakeview Farm is no more, that bend in Mill Road remains. (Courtesy Longwood Public Library.)

Swans are not native to Yaphank's lakes, but Christian Krabbe, a native of Denmark, had them imported around 1910. Krabbe owned many acres of property along the Carmans River, and whenever he sold riverfront property, he retained a 10-foot-wide right-of-way to the riverbank so he could enjoy the river views and his swans. (Courtesy Gary Ralph.)

Christian Krabbe emigrated from Denmark to Brooklyn, where he owned an electrical parts store. He sold early phonographs and is credited with developing the "morning glory horn" for the Edison phonograph. He moved to Yaphank around 1910. Dealing in insurance and real estate, he acquired large tracts of land in Yaphank and was vice president and director of Peoples Bank in Patchogue. (Courtesy Yaphank Historical Society.)

Eight

ALL ROADS LEAD TO YAPHANK

It was once said that all roads lead to Yaphank. Some felt that the saying referred to shopping and patronizing the gristmills and sawmills. Others took a dimmer view and thought that all roads led to the poorhouse there. Yaphank changed when the railroad came through, bringing outside visitors to Yaphank's pastoral setting. And now it was commonplace for villagers to go in and out of the city regularly. (Courtesy Town of Brookhaven.)

A *History of Long Island* by Pelletreau states that James H. Weeks was an early promoter of the plan to build a railroad from Brooklyn to Greenport. He used his influence to run the railroad through his home village of Millville in 1844. He was president of the Long Island Railroad from 1847 to 1850, and the 10th locomotive commissioned was named the *James H. Weeks* in his honor. (Courtesy Robert and Elizabeth Martino.)

According to historian Thomas Bayles, lumbering and woodcutting was a huge industry in Suffolk County until the early 1900s. The coming of the railroad allowed loggers to easily ship wood to New York City for use as fuel and building material. Sparks from the engines caused fires that damaged farm buildings and woodlands. Often livestock were killed after wandering on to the tracks. This created problems between the villagers and the railroad. The railroad finally agreed to pay one half for damages caused. (Courtesy Bayles Collection.)

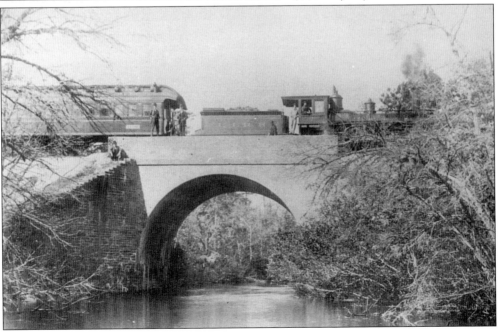

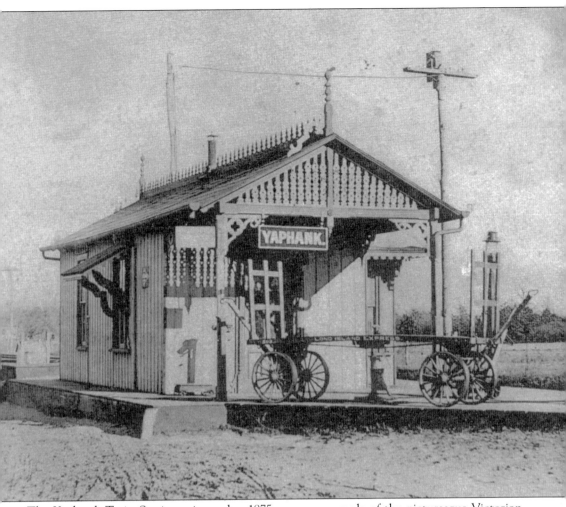

The Yaphank Train Station, pictured c. 1875, was an example of the picturesque Victorian architecture of the day with its Carpenter Gothic details. James Weeks was an early promoter of the plan to build a railroad from Brooklyn to Greenport and used his influence to establish a station in his home village. He later became president of the Long Island Railroad from 1847 to 1850. (Courtesy Edythe Davis.)

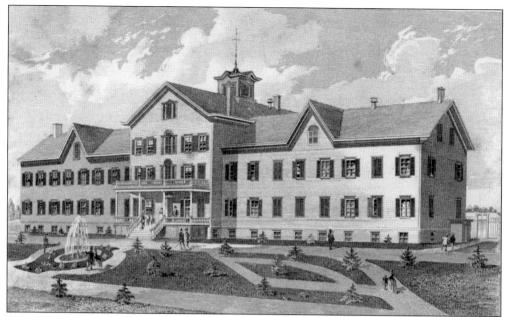

The Suffolk County Almshouse was built on Yaphank Avenue in 1871. L. Beecher Homan writes in *Yaphank As It Is and Was. Its Prominent Men and Their Times:* "The Almshouse was a lovely building with graveled walks, floor to ceiling windows and steam heat. It was considered a state of the art facility." (Courtesy Yaphank Historical Society.)

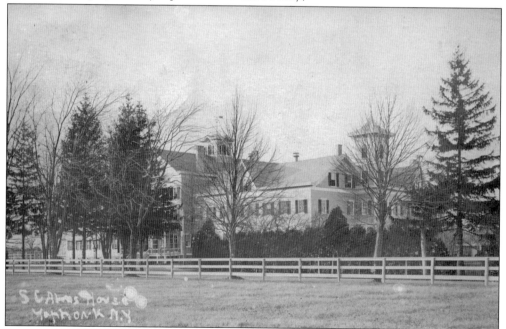

Barbara Rivadeneyra writes that residents of the almshouse were expected to do farm work for eight hours a day except for Sunday. Suffolk County provided the farm implements, seed, and manure for the workers. The harvested crops were used to feed the residents. Meals at the almshouse were hardy and consisted of beef, pork, plenty of vegetables, bread, and butter. (Courtesy Edythe Davis.)

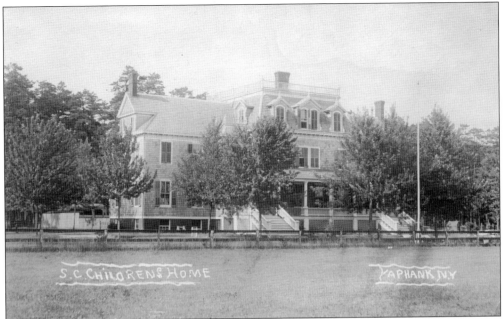

Built in 1896 to replace the old orphan asylum, the Suffolk County Children's Home housed orphans from two to 16 years of age. On average, there were 15–26 children living at the house at any one time. It cost Suffolk County 15¢ per day to feed and clothe each child at the turn of the century. The home stood on Yaphank Avenue opposite the almshouse. (Courtesy Longwood Public Library.)

In 1919, the Suffolk Country Children's Home closed, and the children were placed in foster care. The building had been deemed a firetrap, but Suffolk County added fire escapes and used it as an infirmary for the Suffolk County Almshouse across the street until it was closed in 1935. (Courtesy Edythe Davis.)

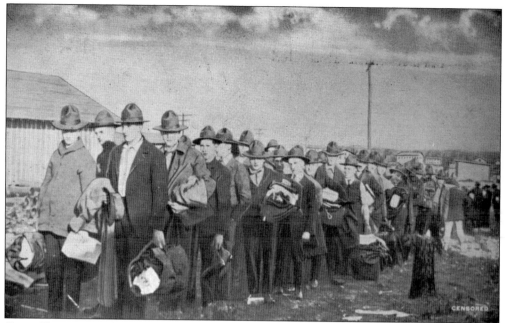

Camp Upton, named after Civil War major general Emery Upton, was built on 10,000 acres as World War 1 started. Historian Osborne Shaw wrote, "When the camp was established, the Yaphank Post Office was the nearest and mail was addressed as Camp Upton, Yaphank, Long Island, New York," as Camp Upton was two and a half miles northeast of Yaphank. Forty thousand men were trained there. (Courtesy David Overton Collection.)

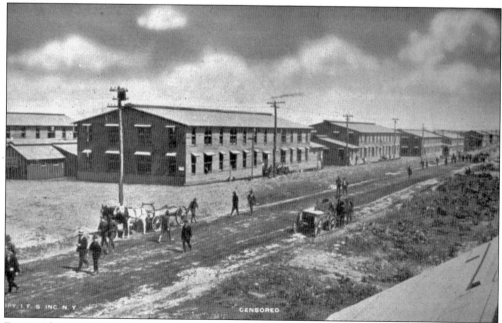

During the initial construction of Camp Upton, the land had to be cleared of scrub pine and dense undergrowth. An intense 16-week training session was in store for the recruits who came from all walks of life and many national backgrounds. (Courtesy David Overton Collection.)

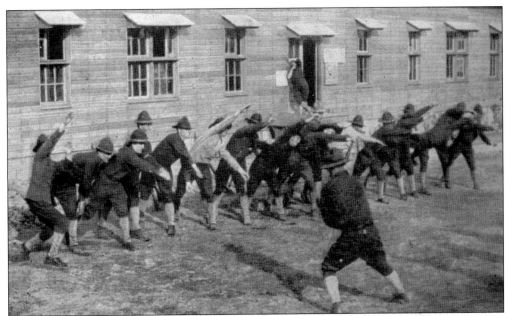

French and British officers were brought to Camp Upton to train American soldiers in the use of hand grenades, machine guns, and hand-to-hand combat. The famed 77th Division was trained at Camp Upton and was recognized for its valor at the Argonne Forest in August 1918. (Courtesy David Overton Collection.)

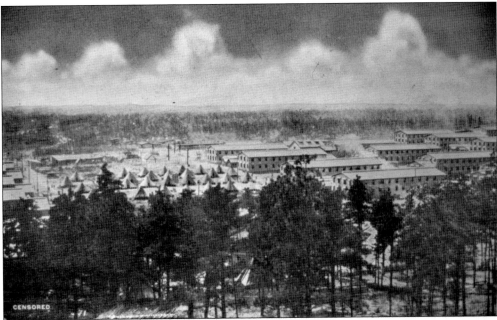

After the war, the camp's buildings and utilities were sold at auction. Small buildings were moved to surrounding areas for use as homes and barns. Camp Upton was completely dismantled and rebuilt in 1940 to be used during World War II. At its peak, the camp's Army doubled the population of Suffolk County. The Brookhaven National Laboratory now occupies the site. (Courtesy David Overton Collection.)

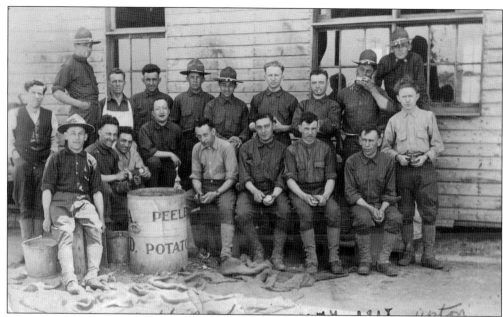

Harold Verity, one of thousands of tristate soldiers who trained at Camp Upton, was pressed into service as a cook (shown in the apron) for the troops in 1918. KP duty, or "kitchen police," a task meaning food prep, was assigned to these soldiers pictured above. They are peeling potatoes, which became iconic when featured in Irving Berlin's *Yip Yip Yaphank*. (Courtesy Lynda Rishkofski.)

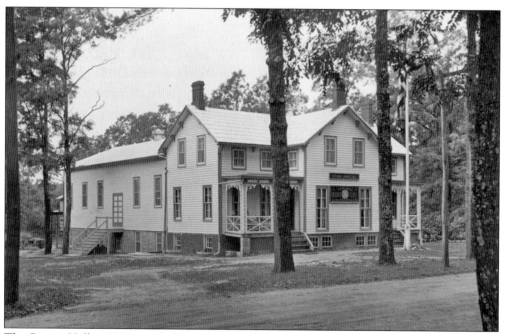

The Grange Hall in 1913 provided a center for community life with theatrical productions, dances, and dinners. With the advent of World War I, a large addition and interior renovation made it a popular soldiers' club. Benefits were held for the Red Cross with an admission of 25¢ for ladies and 50¢ for gentlemen. It still stands on Main Street and is used as a bank. (Courtesy Ann Englehardt.)

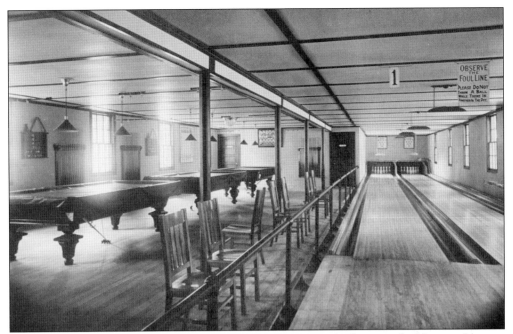

Two lanes for bowling and pool tables provided recreation and relaxation for Upton soldiers at the Grange Hall. Part of the bowling ritual was to set the pins for each game. Behind the Grange Hall is an expansive lawn that extends to the banks of the Carmans River, where boating was a popular diversion. (Courtesy Ann Englehardt.)

The reading room at the Grange Hall was a quiet spot to read or to meet with visiting relatives who could take the train to Yaphank Station. It was known as the soldiers' club during the war, and its central location and comfortable surroundings made it a home away from home for the soldiers. (Courtesy Ann Englehardt.)

Irving Berlin and two doughboys pose in costume for the musical *Yip Yip Yaphank*. One song that Irving Berlin wrote for the musical but decided not to use was "God Bless America." He thought it was not upbeat enough for the comedy. In 1939, Kate Smith sang it on her radio show for Armistice Day. Today, it has become America's unofficial national anthem. (Courtesy Camp Upton History Collection.)

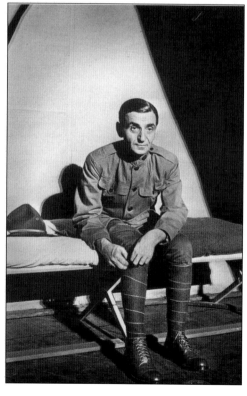

Irving Berlin came to Camp Upton in 1917, and while there, he wrote a musical for the soldiers to perform called *Yip Yip Yaphank*. It featured the song "Oh, How I Hate to Get Up in the Morning." The show was a hit and wound up on Broadway, where it raised $83,000 for the Army. (Courtesy Camp Upton History Collection.)

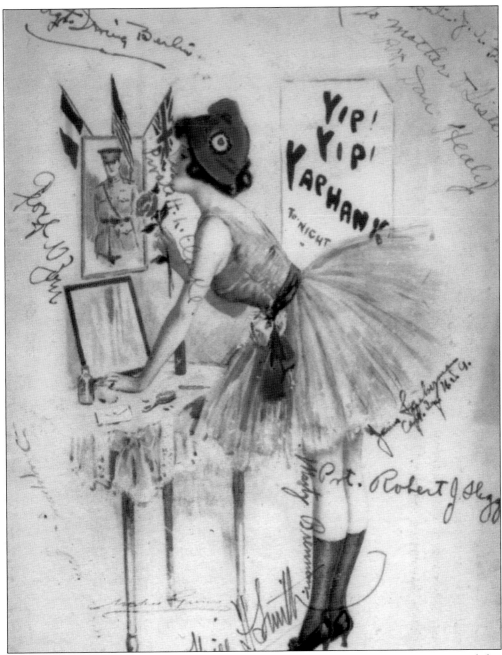

Camp Upton had a major influence on the area, and Irving Berlin played a part in it with his revue *Yip Yip Yaphank*, which was an effort to contribute to the moral of the troops based there. The show went on to reach thousands across the country and put Yaphank on the map. (Courtesy Camp Upton History Collection.)

BIBLIOGRAPHY

Borg, Pamela, and Elizabeth Shreeve. *The Carmans River Story: A Natural and Human History.* Privately printed, 1974.

Bayles, Donald and Paul Infranco, editors. *Early Settlers of Long Island and Their Participation in the American War for Independence.* Middle Island: Longwood Society for Historic Preservation, 2007.

———. *Longwood in the Civil War.* Middle Island: Longwood Society for Historic Preservation. 2002.

Bayles, Thomas R. *Patchogue Advance,* Footnotes of L.I. History, 1946–1967.

———. *Camp Upton During WWI.* Privately printed, 1974.

Chapin, Richard C. *Little Susy's Church, A History of St. Andrew's Episcopal Church.* Yaphank, NY: Privately printed, 2003.

Homan, L. Beecher. *Yaphank As It Is and Was. Its Prominent Men and Their Times.* New York: John Polemus Printer, 1875.

Mather, Fredric. *The Refugees of 1766 From Long Island to Connecticut.* Albany, New York: J.B. Lyon Company Printers, 1913.

History of Suffolk County. New York: W.W. Munsell and Company, 1882.

Pelletreau, William S. *History of Long Island, Vol. II.* New York: Lewis Publishing Company, 1903.

———. *History of Long Island, Vol. III.* New York: Lewis Publishing Company, 1903.

Portrait and Biographical Record of Suffolk County. New York: Chapman Publishing Company, 1896.

Records Town of Brookhaven Up To 1800 As Compiled By The Town Clerk. Patchogue: the *Advance,* 1880.

Rivadeneyra, Barbara. *The Suffolk County Almshouse and Farm Complex 1871–1992.* A paper presented to the Yaphank Historical Society in 1992.

Ross, Peter, L.L.D. *A History of Long Island, Vol. 1.* New York: Lewis Publishing Company, 1903.

THE YAPHANK HISTORICAL SOCIETY

The Yaphank Historical Society was founded in 1974 by a concerned group of citizens committed to saving the historic houses along Main Street and preserving the history of Yaphank. Their first project was saving the Robert Hewlett Hawkins House on Yaphank Avenue, which was derelict and owned by Suffolk County. A partnership was founded between them to restore the house and surrounding area. The Town of Brookhaven created Yaphank's historic district in 1985.

The Hawkins House, at the intersection of Yaphank Avenue and Main Street, is now the headquarters of the historical society and is used for many community functions. About one block away, the restoration of the Mary Louise Booth House was the next project and has been turned into a museum dedicated to the life of this accomplished and celebrated woman. At this same intersection, the Homan Gerard House is the next undertaking in collaboration with Suffolk County Parks Department's Historic Services. One of the earliest houses in Yaphank, built in 1790, is the gambrel roof Federal-style house, vacant since the 1940s and in major disrepair. It is first on the list of endangered properties for Suffolk County, and work will be started in 2012 on saving this important house and its history. Situated on the banks of the Carmans River and across from Lily Lake, its setting is as important as the house, and the society has created a nature trail through the woods and the old Weeks property to the Cranberry Pond and the old Octagon House foundation. An initiative to install period-appropriate fencing and signage in the historic district is well under way, and an active role in saving the lakes is another priority. All of the latest historical society events and projects are on its website, www.yaphankhistorical.org.

DISCOVER THOUSANDS OF LOCAL HISTORY BOOKS FEATURING MILLIONS OF VINTAGE IMAGES

Arcadia Publishing, the leading local history publisher in the United States, is committed to making history accessible and meaningful through publishing books that celebrate and preserve the heritage of America's people and places.

Find more books like this at
www.arcadiapublishing.com

Search for your hometown history, your old stomping grounds, and even your favorite sports team.